13th Century Gateway and Wall

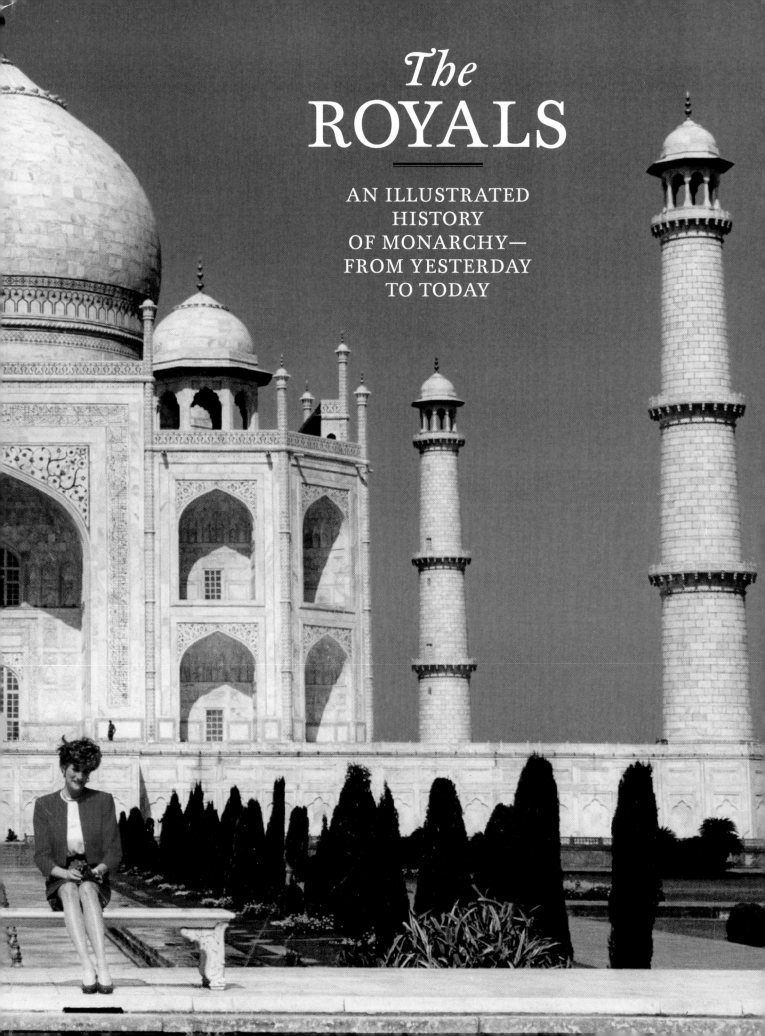

The ROYALS

AN ILLUSTRATED HISTORY OF MONARCHY— FROM YESTERDAY TO TODAY

LIFE Books
Managing Editor Robert Sullivan
Director of Photography Barbara Baker Burrows
Creative Director Richard Baker
Deputy Picture Editor Christina Lieberman
Writer-Reporter Hildegard Anderson
Copy Kathleen Berger,
Barbara Gogan, Parlan McGaw
Consulting Picture Editors Mimi Murphy (Rome),
Tala Skari (Paris)

President Andrew Blau
Business Manager Roger Adler
Business Development Manager Jeff Burak

Editorial Operations Richard K. Prue (*Director*),
Brian Fellows (*Manager*), Keith Aurelio,
Charlotte Coco, Tracey Eure, Kevin Hart,
Mert Kerimoglu, Rosalie Khan, Patricia Koh,
Marco Lau, Brian Mai, Po Fung Ng,
Rudi Papiri, Robert Pizaro, Barry Pribula,
Clara Renauro, Hia Tan, Vaune Trachtman

Time Home Entertainment
Publisher Richard Fraiman
General Manager Steven Sandonato
Executive Director, Marketing
Services Carol Pittard
Director, Retail & Special Sales Tom Mifsud
Director, New Product Development Peter Harper
Development & Marketing Laura Adam
Publishing Director, Brand Marketing Joy Butts
Assistant General Counsel Helen Wan
Book Production Manager Suzanne Janso
Design & Prepress Manager
Anne-Michelle Gallero
Brand Manager Roshni Patel

Special thanks: Christine Austin, Jeremy
Biloon, Glenn Buonocore, Jim Childs, Susan
Chodakiewicz, Rose Cirrincione, Jacqueline
Fitzgerald, Carrie Frazier, Lauren Hall,
Malena Jones, Brynn Joyce, Mona Li, Robert
Marasco, Amy Migliaccio, Kimberly Posa,
Brooke Reger, Dave Rozzelle, Ilene Schreider,
Adriana Tierno, Alex Voznesenskiy, Sydney
Webber

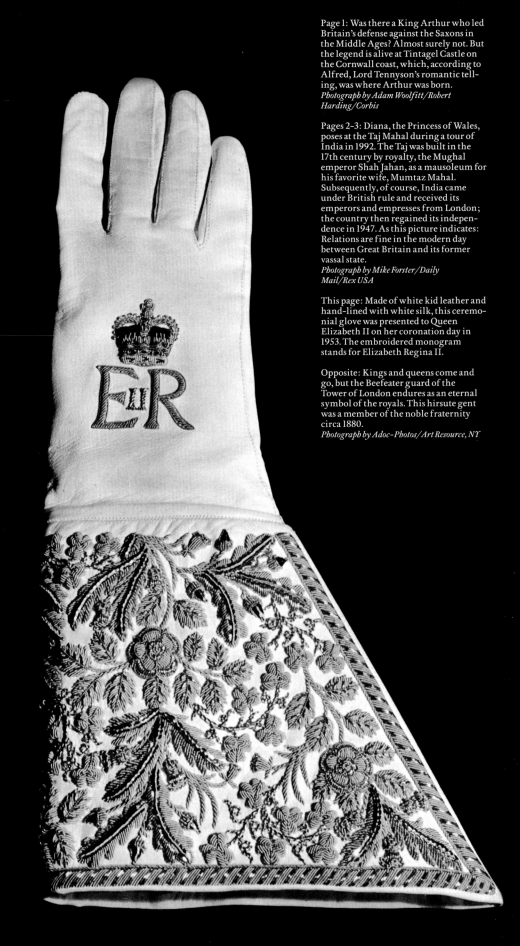

Page 1: Was there a King Arthur who led
Britain's defense against the Saxons in
the Middle Ages? Almost surely not. But
the legend is alive at Tintagel Castle on
the Cornwall coast, which, according to
Alfred, Lord Tennyson's romantic tell-
ing, was where Arthur was born.
*Photograph by Adam Woolfitt/Robert
Harding/Corbis*

Pages 2-3: Diana, the Princess of Wales,
poses at the Taj Mahal during a tour of
India in 1992. The Taj was built in the
17th century by royalty, the Mughal
emperor Shah Jahan, as a mausoleum for
his favorite wife, Mumtaz Mahal.
Subsequently, of course, India came
under British rule and received its
emperors and empresses from London;
the country then regained its indepen-
dence in 1947. As this picture indicates:
Relations are fine in the modern day
between Great Britain and its former
vassal state.
*Photograph by Mike Forster/Daily
Mail/Rex USA*

This page: Made of white kid leather and
hand-lined with white silk, this ceremo-
nial glove was presented to Queen
Elizabeth II on her coronation day in
1953. The embroidered monogram
stands for Elizabeth Regina II.

Opposite: Kings and queens come and
go, but the Beefeater guard of the
Tower of London endures as an eternal
symbol of the royals. This hirsute gent
was a member of the noble fraternity
circa 1880.
Photograph by Adoc-Photos/Art Resource, NY

CONTENTS

Introduction:

Rules of
THE ROYALS

Members of royal families are different from you and us, and not only in that they have lots more jewelry and rather astonishing headwear. They approach life differently. They have a far different sense of entitlement. They have different expectations. And, yes, they have to wear all that jewelry and the funny hats. On a daily basis.

They are sometimes hard to understand, and by that we don't mean to say that they are hard to understand when they chop people's heads off or otherwise misbehave in what polite society would deem to be egregious ways. What we mean is: It's often difficult for us commoners to understand what in the world is going on in the world of royals.

Who made him the king?

Why is a German the queen of England?

How can you usurp a throne?

What's a claimant?

We would urge that, after you turn the page on this introduction to our book, you simply don't worry and be happy. To understand the rules of the royals is an almost impossible task for those of us not born into their rarefied strata.

Having said that, however, we do feel it necessary to give you a few tips—the briefest primer—before you proceed on your visit to the regal realm.

A monarchy is, essentially and historically, a form of government in which power resides in an individual—a king or queen—who is at bottom a dictator with a nicer appellation and fancier clothes. In the olden days, monarchies constituted a globally widespread societal structure. Republics and democracies were unheard of in the Middle Ages and, to give an example close to home and more recent, until the colonies that became the United

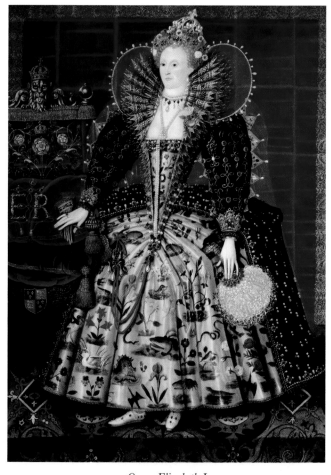

Queen Elizabeth I

States forcibly threw off England's shackles, we, too, were ruled by a king—whom you will meet on page 27.

There are today more than three dozen nations that still recognize a monarch as their "leader," but in many of them, the game has changed. For instance, 16 of these nations, including biggies such as Australia and Canada as well as such territories as the Falkland Islands, are Commonwealth realms, looking up to Great Britain's

Queen Elizabeth II. As we know, she has little more than ceremonial power these days. England long ago shifted from an absolute monarchy to a constitutional monarchy, with democratically elected officials, headed by the prime minister, calling the shots day by day. Nevertheless, England still has a queen and will one day have another king. He will be world famous and celebrated—just as Elizabeth is today, as the first Elizabeth was in her era (when the monarch really controlled things) and as her father, Henry VIII, perhaps the most notorious king in world history, was before her.

Which brings us to another rule about royals: They fascinate us. They are and have always been celebrities in ways that dictators, prime ministers and even Presidents cannot be (a possible exception being John F. Kennedy). It must be in the DNA . . . and the accoutrements. Why was the wedding of Prince Charles and Lady Diana a global television event on the scale of a World Cup soccer final? Why will the wedding of Prince William and his lovely bride be the same?

The snide answer is, "Beats me!" We must realize, however: We Americans are complicit in this. It's why you hold this book in your hands. There is a magnetism to royalty—particularly, for us, British royalty—that cannot be denied. In its otherworldly opulence and extravagance, its periodic romance and even in its sometimes outrageous behavior, royalty is riveting. It's entertaining. It's . . . a kick.

Particularly so today. In modern times, the British royals, essentially stripped of real power and therefore the ability to do real harm, can be looked at in a different light. The peasants were probably not amused by Henry's antics and his toying with their religious traditions; they surely lived in dread of the crown. Today, royals are a lark. Di and Fergie: endlessly fascinating. Monaco may be as inconsequential as a nation can be—unless you're seeking a tax haven. But when Grace Kelly of Hollywood and, earlier in life, the wealthy Philadelphia Kellys, became a real-world princess, the entire affair could be indulged in as a Disney confection. And Grace's own beautiful daughters came of age just as *People* magazine did.

This all reflects, we hope, the attitude of our book: This is fun stuff. We include history, to be sure, because we find that fun as well. We include fine photography of the palaces we all visit when touring England, and of that splendid jewelry. We focus, almost exclusively, on the British monarchy under the twin assumptions that it is the most famous and the one that most fascinates Americans.

We do not try to untangle that which cannot, succinctly and logically, be untangled. It would be a waste of our time and yours. Still, here are a few last rules to help you navigate the verbal and pictorial narrative that follows:

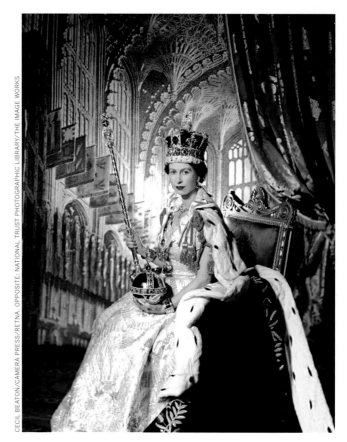

Queen Elizabeth II

Who made him the king? Often, he did. The fellow with the biggest sword.

Why is a German the queen of England? Because, often, strategic alliances have been forged through wedlock. As you will learn, the first of Henry VIII's half-dozen unfortunate spouses was Catherine of Aragon. Aragon was part of Spain. That marriage was precipitated by Henry's father, who wanted to cozy up to Isabella and Ferdinand. You'll meet the German queen on page 34.

How can someone usurp a throne? See Biggest Sword Theorem, above.

What's a claimant? Someone who thinks that he or she should be on the throne and isn't. Someone in the market for a bigger sword.

This last answer begs a final question that baffles many in the American audience and is worth asking as we begin our journey: What's with all these "houses"? The Plantagenets, the Lancasters, the Yorks, the Tudors? Who are these Windsors? The answer is that, basically, these are all families; they hand down the crown until the lineage runs dry and then a distant relative might be found in another family with a different surname, or they may simply change the surname, as the Windsors did, or a guy with a really big sword might come along and . . .

Don't worry, be happy. And please enjoy our fun look at the royals—yesterday, today and most likely tomorrow.

The
CROWN

On the opposite page is one of the
most iconic emblems of Britain's
royals, the Imperial Crown of
State, which is today kept in the
Tower of London. It is not nearly as
old as the kingdom of England itself,
though it does contain principal
surviving historic jewels dating to the
ancients: Its dominant sapphire
was once part of a ring owned by
Edward the Confessor, who died in
the seminal year 1066. Few things
speak of the power and glory
of monarchy as does the crown itself.

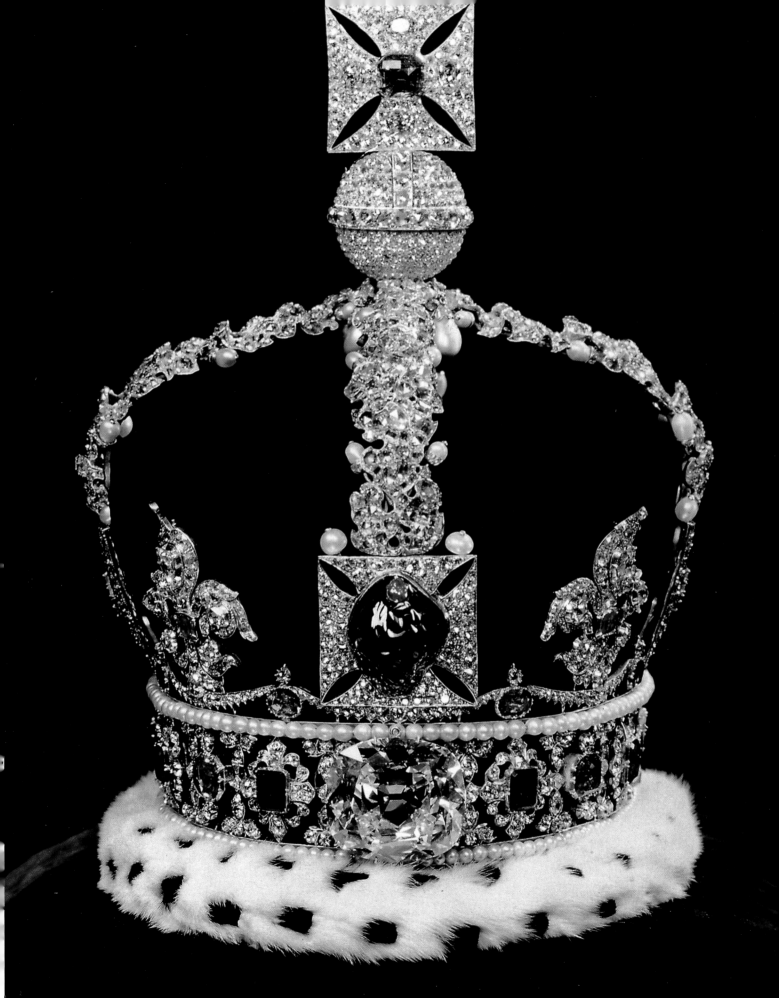

A KINGDOM FORMS

As mentioned moments ago in our introduction, the history of the English monarchy is hopelessly tangled, and to apprehend its rhyme and reason and trajectory quickly is a nigh impossible task; flowcharts only seem to confuse the matter further. But under the rule that we must start somewhere, we begin in the first half of the ninth century A.D. What had happened already: The Stonehenge builders had had their era (the first stones of that monument were set in place circa 3100 B.C.); the Romans had come and established the province called Britannia; the Anglo-Saxons (the direct ancestors of the English) had built minor kingdoms in the former Roman state, many minor kingdoms that eventually coalesced into seven semimajor ones. By the year 825, one of these, Wessex, home of the West Saxons, dominated rival fiefs such as Kent and Sussex and was emerging as a top dog. In 827, Northumbria, too, submitted to Wessex, and with this triumph King Egbert, who had led his people on their upward climb since 802, became, de facto, "Ruler of Britain"—as the hallowed *Anglo-Saxon Chronicle*, written later in the century, put it.

If Egbert is seen as the first leader to reign over a united England, it must be quickly noted that his coalition was short-lived, and by the time of his death in 839 the nation-state as he had assembled it had been sundered. Since we cannot deal in our limited pages with all or even many of the monarchs who followed Egbert, nor with all of the permutations that came to constitute "England" or the "British Empire," we focus next on the life and times of Alfred the Great, king of Wessex from 871 to 899, who was awarded his grandiloquent epithet— the only native English king ever to be called Great—in thanks for his noble and successful defense of the homeland against invading Vikings. Alfred struggled early in his career to hold everything together, but he retook London in 886 and firmly established himself as overlord of the English. It was he who set the nation on a course it would long follow, reforming the legal system, boosting education, building a strong army and navy, encouraging religious observation (he was a Catholic, and the contemporary Anglican Communion celebrates his feast day every October 26). It can be claimed that, with Alfred the Great, the country's rise began.

Egbert is at left and Alfred above. Right: The hill carving in this picture is the Westbury White Horse, the oldest of several similar figures carved into promontories in Salisbury Plain. An impossible-to-prove legend holds that it was created to commemorate Alfred's triumph over the Danes in 878 at the Battle of Edington. Whether or not that was the case, the white horse has become a potent symbol emblazoned on English war standards.

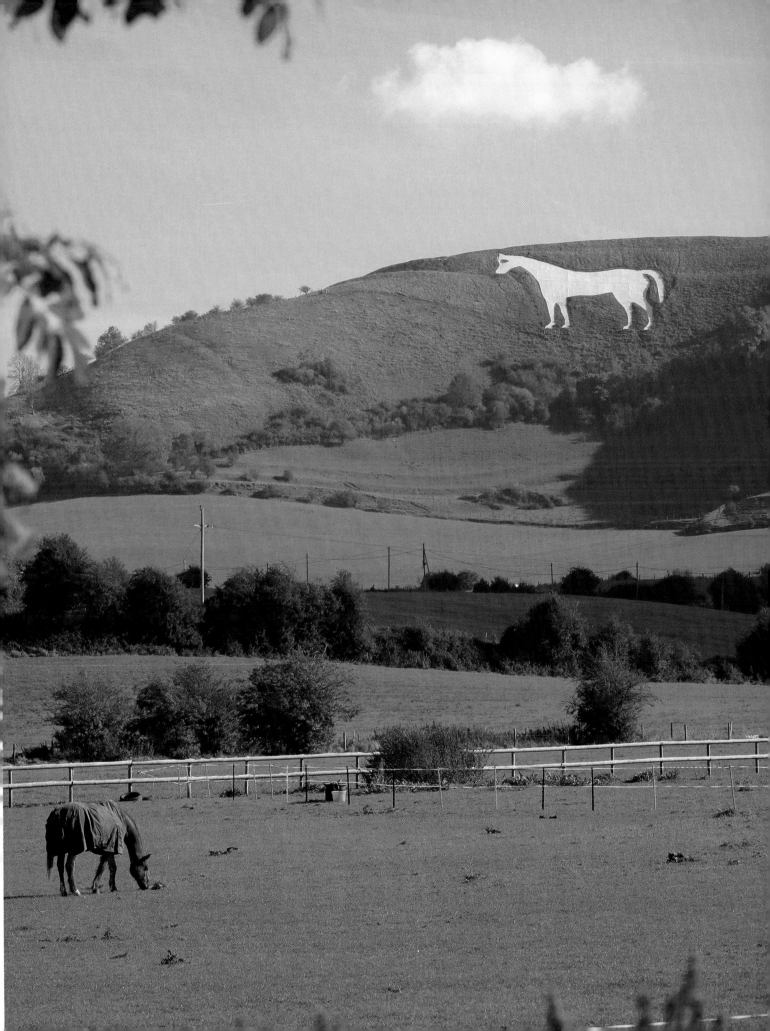

PEACEFUL AND NOT

The men on these pages signify the near-constant turmoil that swirled in and around the kingdom. Ruling from 959 to 975 was Edgar the Peaceful, another man from Wessex, who seized two kingdoms from his brother, Eadwig, before settling into his indeed peaceful reign, *peaceful* being a rather relative term in the Middle Ages. Edgar is credited with greatly solidifying the kingdom envisioned by predecessors such as Egbert and Alfred. After Edgar, England would not again split internally into warring kingdoms.

Which is not to say that England was immune to pressures from beyond its by now well-defined borders. In fact, Edgar's solid tenure was followed in succession by three foreign conquests of the nation and the gradual demise of Anglo-Saxon Britain. First, the Vikings invaded, ousting Aethelred II—ignominiously known by history as Aethelred the Unready—and Sweyn I of Denmark took over. When Sweyn died in 1014, Aethelred was restored to the throne, but briefly, as he was still Unready: The very next year, Sweyn's son, Canute, invaded, the Vikings won again and a rule that would last 26 years was established. Canute, like Alfred of Wessex, was known as "the Great," and, like Alfred, he rather *was* that. Of Danish and Polish descent, he was king not only of Denmark and England, where he lived out his days (he's buried in Winchester Cathedral) but also of Norway and parts of Sweden. Something of an iconoclast in the medieval era, he assayed to keep his kingdom intact by building cultural bridges and growing the general wealth rather than by wielding the cudgel—and by and large, his tactics worked. But his empire would not last much beyond him. He died in 1035, and his heirs followed him to the grave within a decade. This next transfer is as complicated as any in British history: Canute and the widow of Aethelred the Unready, Emma, had a son named Hardicanute, who died on the throne in June 1042. Hardicanute was childless and therefore was succeeded by Aethelred's son—Hardicanute's own half brother—Edward the Confessor. England was again ruled by an Englishman. When (the also childless) Edward died in 1066, his brother-in-law was crowned King Harold.

Edward's cousin the Duke of Normandy, known as William the Bastard, was immediately displeased. He wanted the crown for himself and claimed it. He landed in Sussex on September 28 to press his point.

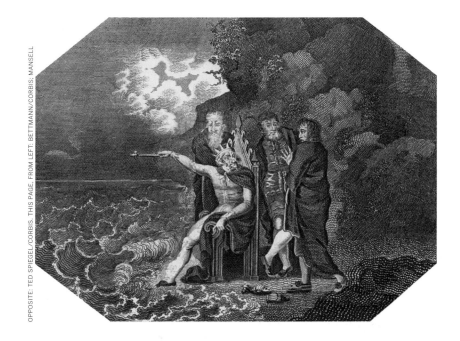

At left is Canute trying to hold back the waters of the sea and below is Edgar being transported on the waters. Opposite: In the northeast of England are many and varied remnants of the epoch when the Vikings were in play, including these ruins of a fort said to have been used by Canute in the 11th century. The Vikings often renovated antiquated coastal fortifications left over from Britain's Roman period.

Below: The Bayeux Tapestry is a swath of woven linen some 230 feet long and 19½ inches wide, depicting dozens of events leading up to and including the critical Norman Conquest; it was probably made within a decade of the episodes it records. In this section, King Harold and his men are being routed at Hastings. Opposite: The White Tower represents William the Conqueror's founding contribution to what became the vast Tower of London complex.

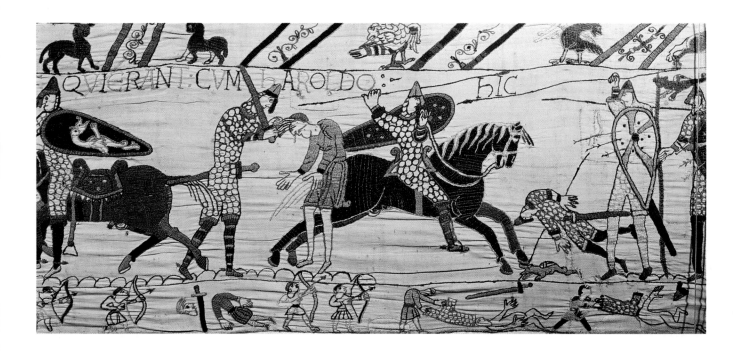

THE GAME-CHANGING NORMAN CONQUEST

The face-off between King Harold and William of Normandy, which took place in the south of England at the Battle of Hastings on October 14, 1066, found the monarch at a disadvantage, as he and his army were still recovering from a strenuous if successful fight with the Norwegians (everyone was fighting with everyone at the time; the Viking king Harald III of Norway also thought he, not Harold, should rightfully be the new king of England). William the Bastard, soon to be better known as William the Conqueror, won at Hastings, where Harold died in battle, and then won everywhere else in England, and on the 25th of December was crowned the country's king. William's army had consisted of not only Normans but soldiers from Brittany and France as well, and the flavors of these foreign lands seeped into British culture during his reign; in the Middle Ages, this island state (William invaded Wales too) was becoming as cosmopolitan as a medieval enterprise could be. William would fall off his horse in 1087 while on a campaign in France and would subsequently die of his injuries at age 59. Nonetheless, his legacy would be great. Despite the squabbles of his sons concerning who had the right to rule, the state of the kingdom of England was strong: The Norman Conquest marked the last time the nation would fall to a foreign power, Hitler's Nazis be damned. There was eventually, as we know, a separation and many conflicts between Britain and William's native France. But it is indicative of this man's vast influence that when a monument was erected in the Norman town of Bayeux to commemorate the Allied success in liberating France in World War II, the inscription read, "We, once conquered by William, have now set free the Conqueror's native land."

William's legacy is great and it is also tangible—and tourist friendly. Admixing Caen stone imported from France with more easily gotten and more massive quantities of Kentish ragstone, William completed the construction, in 1078, of the White Tower and its Norman-style chapel, now the centerpiece of the Tower of London complex. Though Shakespeare would say in *Richard III* that Julius Caesar built the 90-foot-high Tower, William did. Whether he attracted the first of the Tower's many generations of fabled ravens is uncertain, and it's worth noting that the Tower was never used as a prison or place of execution during his reign. He also built, in the Berkshire countryside starting in 1070, the beginnings of Windsor Castle, which today is, at 484,000 square feet, the largest inhabited castle in the world, as well as one of the three principal official homes (along with Buckingham Palace and the Palace of Holyroodhouse in Edinburgh, Scotland) of Queen Elizabeth and Prince Philip.

Today we can sense William's importance as we walk the halls of his formidable estates. We can almost touch him.

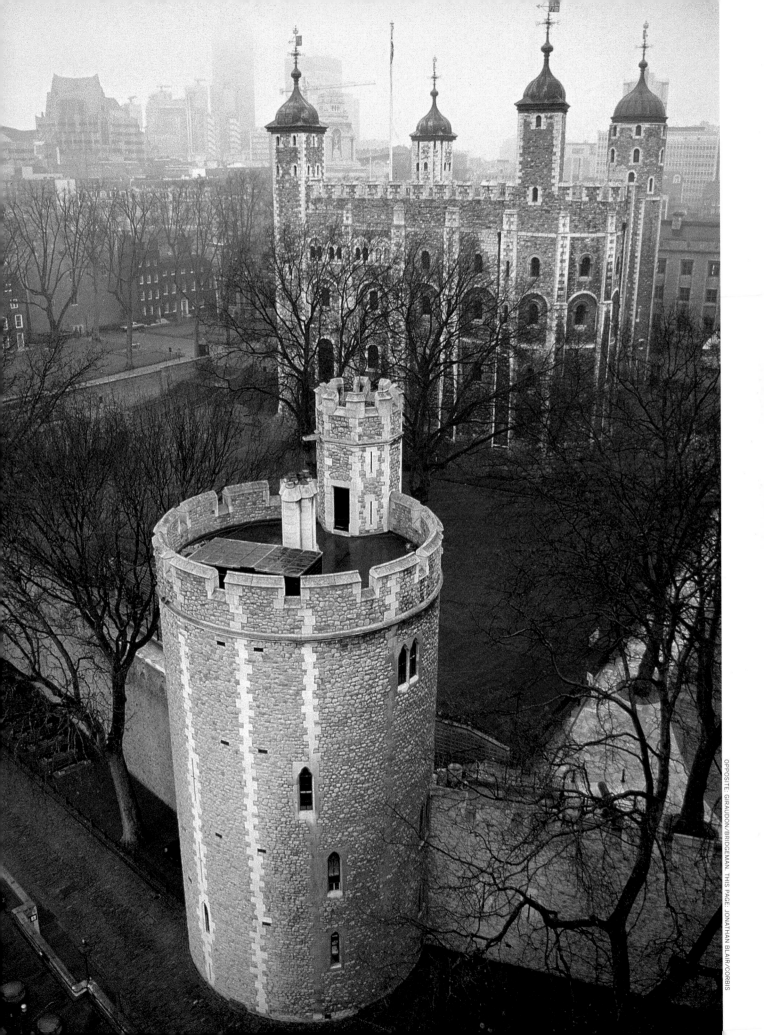

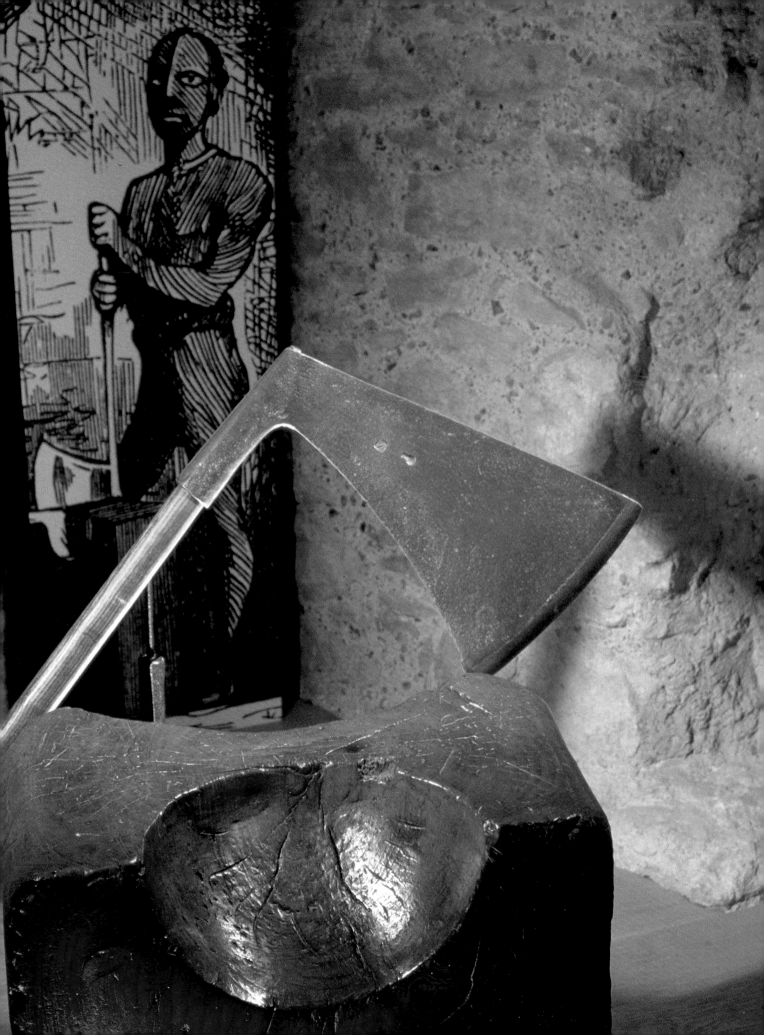

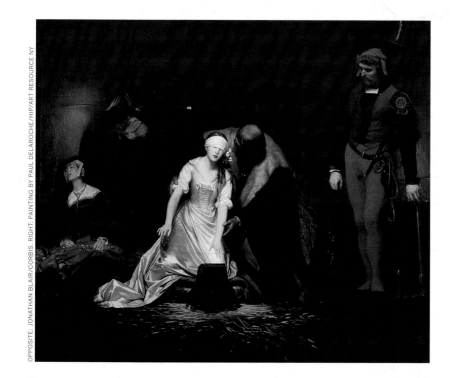

OPPOSITE: JONATHAN BLAIR/CORBIS. RIGHT: PAINTING BY PAUL DELAROCHE/HIP/ART RESOURCE NY

SCALA/ART RESOURCE NY

There was much pomp and circumstance and equal amounts of gloom and doom within the Tower's walls in the centuries after William had the place built. It is most notorious historically as a place of harsh and sometimes unjust imprisonments, torturous punishments and interrogations, and several beheadings. Opposite is a chopping block that was used to end the life of an insurrectionist against the crown, Lord Lovat, in 1747; he was the last person to be put to death in this manner at the Tower. Preceding him in the grisly fate was, among others, Lady Jane Grey (above), the so-called Nine Days Queen, who was executed in 1554 after a preciously short time on the throne, yet another victim of England's Protestant-Catholic wars (she was a Protestant; her successor, Mary I, was not). Above right is the cell to which Sir Thomas More was relegated in 1534, before losing his head one year later. He had been a top counselor to Henry VIII but was a devout Catholic who publicly refuted the notion that the king was the Supreme Head of the Church of England, a refutation at which Henry, of whom we will learn much more on page 23, took severe umbrage. The martyred More is today a Catholic saint. As said, while the Tower was a house of horrors for some, it was a source of great comfort and splendor for those in charge, as symbolically represented by the famous and priceless crown jewels, which still reside in the Tower today, a bare sampling of which is seen at right.

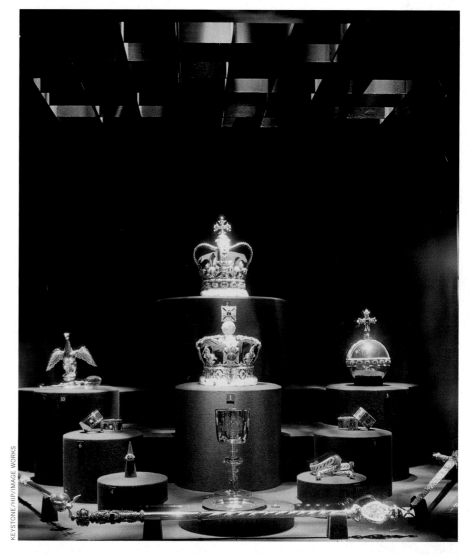

KEYSTONE/HIP/IMAGE WORKS

The British royals today are members of the hallowed House of Windsor, but in fact there was no House of Windsor until World War I when the descendants of Queen Victoria thought it prudent to throw off their Germanic family name in favor of an English one. There has been, however, a Windsor Castle ever since the first iteration was built of wood in the Berkshire countryside by William the Conqueror between 1070 and 1086. The castle has a history every bit as fascinating as the Tower of London's and more interesting than that of Buckingham Palace. William used it exclusively for military purposes; it was a bulwark of London's defense. His youngest son, King Henry I (of whom we will learn more on the very next page), was the first monarch to live in the castle. Beginning with the 12th century reign of Henry II, Windsor was transformed from William's wooden fortress to a massive stone pile. There are, of course, scores—nay, hundreds!—of anecdotes associated with this royal residence. When the bubonic plague hit London during the reign of the famous Elizabeth I, she removed herself to Windsor and, so fearful of the fever, had a gallows erected there and issued an order that anyone venturing near from the inner city should be executed. On the other hand, when the Nazis started blitzing London during World War II, King George VI and Queen Elizabeth refused to flee to the countryside, hoping to send a message of stoicism by remaining squarely in harm's way at Buckingham Palace, though they did relocate their two daughters to Windsor. Most recently, the big question regarding the castle is whether Sarah Ferguson, the ex-wife of Prince Andrew who, in May 2010, was exposed for soliciting an exorbitant fee for special access to her former husband, will be allowed to keep her quarters near Windsor (please see page 96). Was this the final straw vis-à-vis the heretofore unsinkable Fergie? Will she be thrown out on her once royal fanny? The next chapter in the history of Windsor—and the Windsors—remains to be written.

As Dastardly As Shakespeare's Imagining?

T he eternal Bard is legendary beyond all other writers for many plays commonly grouped, as they were in the First Folio, in three categories: tragedies, comedies and "histories." The last of these included dramas dealing with early English monarchs, unspooling stories that, at most intervals, could easily be classified as tragedies. They also involved plots and intrigues almost beyond credulity—could anyone actually be that rotten? The quickest glance at the behavior of any random sampling of British monarchs leads to an instant answer: Well, sure . . . and in fact, worse. Take Henry I (please!). His notoriety begins with his seizing of the throne in 1100 while his eldest brother, Robert, was away taking part in the first wave of the Crusades, a seizure cemented when he defeated Robert for good in 1106 after many battles. So he is an exemplar of a scheming, stop-at-nothing king. And he is still today the all-time British champion in another royal sport: wanton licentiousness. He was married twice; okay, fine, no big deal. Outside of wedlock, however, he fathered between 20 and 25 illegitimate children with an unknowable number of women. In a field crowded with ripe and ready contenders to the throne as Most Randy King, Henry prevails. As an aside, such energetic bastardy does nothing but set up a kingdom for endless future battles as to who is the rightful heir to a given throne.

And now: Take Richard III. He was the last king of the House of York, ruling for only two years beginning in 1483 and ending with his death at the hands of Henry Tudor's forces in the critical conflict of the War of the Roses, the Battle of Bosworth Field. But let's not focus on his end as king, but on his beginning. His brother Edward IV died in April 1483. The next two in line of succession were the late king's sons, Edward V and Richard, Duke of York. But they were only 12 and nine years old, respectively, and so Uncle Richard was declared Lord Protector of the adolescent king. Some protector! Even as Richard's marketing machine pumped out misinformation about his brother's marriage to Elizabeth Woodville—misinformation that implied the boys were bastards and thus ineligible to be royals—Richard greeted the boys warmly at the Tower of London. Shortly thereafter he seized power, the boys disappeared and were probably murdered; today, the room where they might have been done in is among the many chilling attractions on a Tower tour. Shakespeare exaggerated Richard's humped back to make him more ghoulish still. Richard has supporters today who say he was an accomplished military leader and monarch, but Shakespeare clearly bought the Tudor line: that the man was a monster.

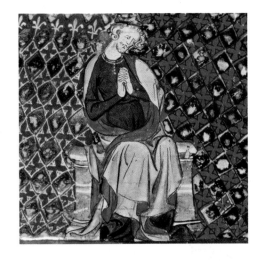

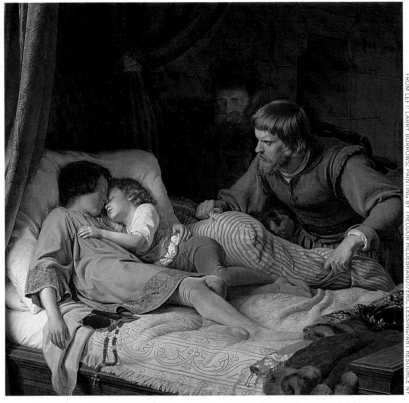

Above: Henry I, youngest son of William the Conqueror and a man who was mightily profligate of seed. Opposite: Richard III, a grasping man who was upright in neither posture nor scruples, at least according to Shakespeare. The Bard bought into the historical rumor, which may well have been based on fact, that Richard ordered the two princes, sons of his late brother Edward IV and thus ahead of him in the line of succession, murdered in the Tower of London (right).

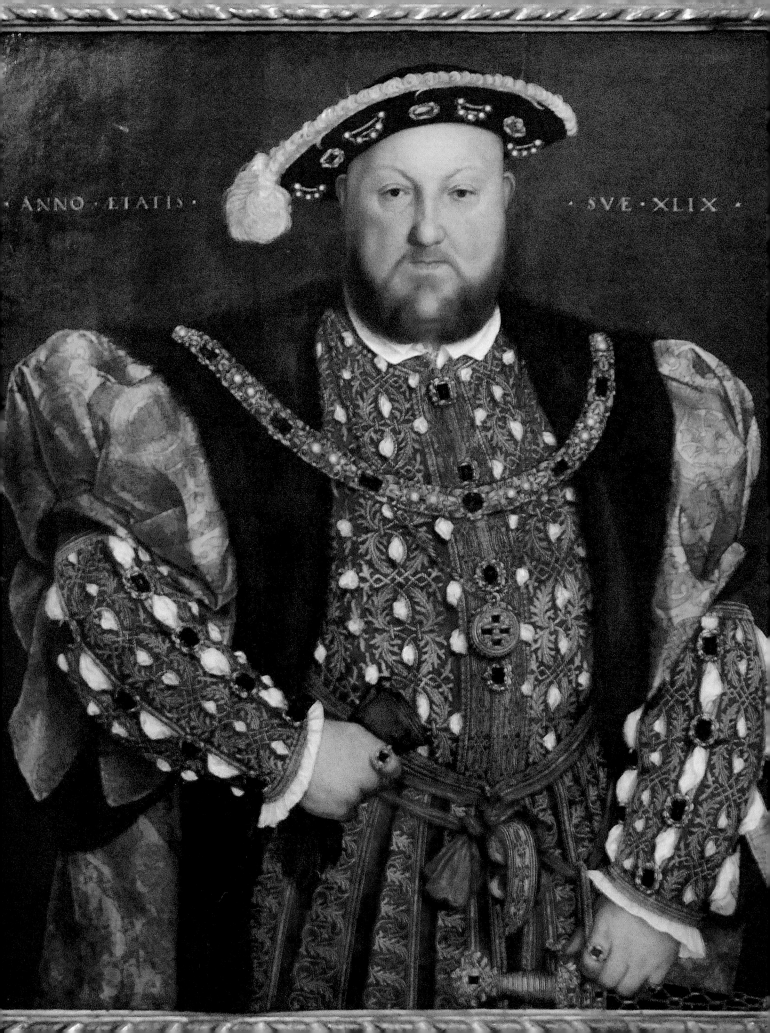

·ANNO·ETATIS· · SVE·XLIX·

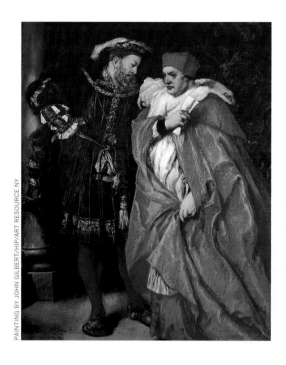

PAINTING BY JOHN GILBERT/HIP/ART RESOURCE NY

I'm 'Enery the Eighth, I Am

Herman's Hermits, the popular '60s band fronted by the perky Brit Peter Noone, had a jolly hit song referencing this most famous and perhaps most influential of all British kings, who also exerted himself as King of Ireland and as a claimant to the French throne. The man himself, Henry—smart as a whip and the first well-educated English monarch; a musician and poet as well as a scholar—cannot be said to have been a jolly fellow at heart. In fact, in terms of personality and deeds done, he can be judged as a combination of the more unattractive traits of the two men we've just met, Henry I and Richard III. Henry VIII was lustful for absolute power, generally unscrupulous, vigorously self-absorbed, nothing if not demanding, and extremely harsh on women.

He became the second king of the House of Tudor in 1509, succeeding his father, Henry VII, the man who prevailed over Richard III at Bosworth Field and thereby brought an end to the House of York's rule. It should be noted that Henry's adventures and misadventures in marriage, for which he is supremely renowned and which had a direct impact on his governance, were jump-started not by his own youthful yearnings but by his dad's ambition. Henry VII felt that an alliance with Spain would be much to Britain's benefit, and that such a bond could be forwarded by offering Henry, then Prince of Wales, as the new husband to widowed Catherine of Aragon, the youngest surviving child of King Ferdinand II and Queen Isabella I (most prominent historically as the sponsor of Christopher Columbus's voyage to the New World). Catherine's and Henry's parents, devout Catholics all, had to receive a papal bull for the marriage to be made since Catherine's late husband, who had died at age 15, was Henry's older brother Arthur (Leviticus: "And if a man shall take his brother's wife . . . they shall be childless"). But this proved little problem, as Pope Julius II cordially granted the dispensation. Thus began Henry's troubled quest for a male heir, setting England on a course that would lead to the creation of a new Christian faith. We will learn more about the wives of Henry VIII and the significance of their often-too-brief biographies on the pages immediately following, but the crucial point is this: Henry, because of his dealings with Rome (five different popes, including Paul III, who was not as compliant as his four predecessors), finally split from the Church and established a national religion, which became Anglicanism and its related Episcopal faiths.

When Shakespeare got around to his play concerning this outsize monarch, he entitled it *The Famous History of the Life of King Henry the Eight*. That history was famous in the Bard's day and remains so in ours.

Henry VIII is remembered for two crucially interrelated issues: his many wives (a role that could prove lethal) and leading England on its own religious course independent of Rome. Above: The king confers with Cardinal Thomas Wolsey, who during more than a decade as Henry's chief counselor was one of the most powerful chancellors in English history. When Henry wanted his marriage to Catherine of Aragon annulled so he could marry Anne Boleyn, Wolsey failed in his efforts to convince the pope to grant the decree and was thereafter stripped of his office and powers. He died of illness before he could be executed. Below: Eighty-three peers of England, represented here by their signatures and seals, approved this document outlining the Anglican schism, paving the way for Henry to wed Anne.

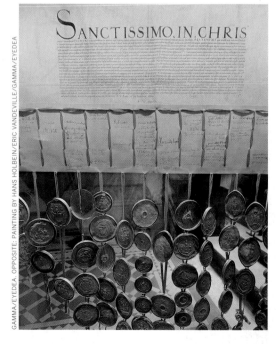

GAMMA/EYEDEA. OPPOSITE: PAINTING BY HANS HOLBEIN/ERIC VANDEVILLE/GAMMA/EYEDEA

DIFFICULT ROLE: WIFE OF HENRY VIII

"**D**ivorced, beheaded, died; divorced, beheaded, survived." So goes the playground rhyme recounting the sequential fates of Henry's six—count 'em, six!—wives. Their cumulative history represents a Tudor Era drama that could have been titled *Mission: Impossible*. "Your assignment, if you decide to accept it . . ."

As we have learned, Catherine of Aragon was first—at the strenuous urging of Henry's dad. Whether the dire warning from the Book of Leviticus had any bearing or not, Catherine experienced great and no-doubt painful difficulties in bearing the king's children. She gave birth to an unnamed daughter on January 31, 1510, who died two days later; to Henry, Duke of Cornwall, on January 1, 1511, who died 52 days later; to a second Henry, Duke of Cornwall, in December of 1514, who died within the month; to a daughter, Mary, on February 18, 1516, who would marry Philip II of Spain and would become England's Queen Mary I and would be succeeded by her half sister Elizabeth; and an unnamed daughter in November 1518, who died within a week. Henry VIII, despairing of his wife's inability to supply a male heir, had their union dissolved (by the good graces of the Archbishop of Canterbury). Next up was Anne Boleyn, who bore only the aforesaid Elizabeth (of whom we will learn more on the following pages) and who lost her head on the chopping block at the Tower of London on May 19, 1536. Jane Seymour followed, indeed bearing a son who would become the briefly reigning (six years) King Edward VI upon his father's death (after an impressive 37 years on the throne) in 1547. Jane died young in 1537 and was succeeded by Anne of Cleves, whose wedding on January 6, 1540, led to a marriage that ended in divorce in barely half a year. Henry married Catherine Howard in July 1540 and had her executed in February 1542. The following year he wed Catherine Parr, who by the grace of God survived him when he died four years later.

Meantime, on December 17, 1538, Pope Paul III, in his fourth year on Saint Peter's Throne, excommunicated Henry VIII for, at bottom, his serial petitions for annulments, his generally bloody ways, and his gradual assertion of dominion over how and why and where and when England would honor God. The kingdom became a nation with a state religion, and Henry set himself up as a kind of papal king.

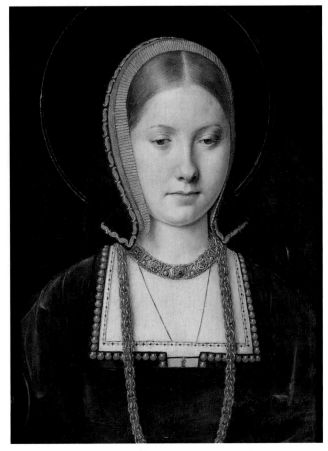

Catherine of Aragon

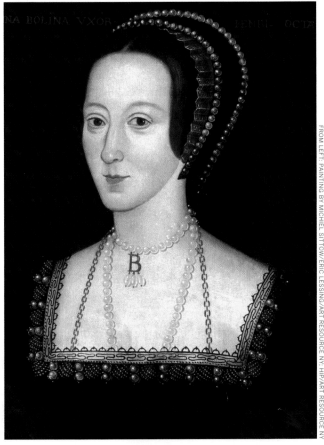

Anne Boleyn

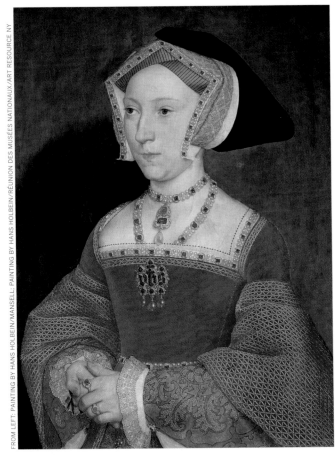

Jane Seymour

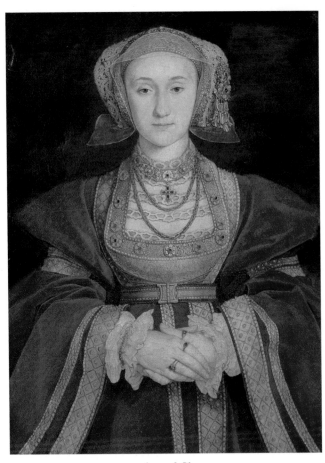

Anne of Cleves

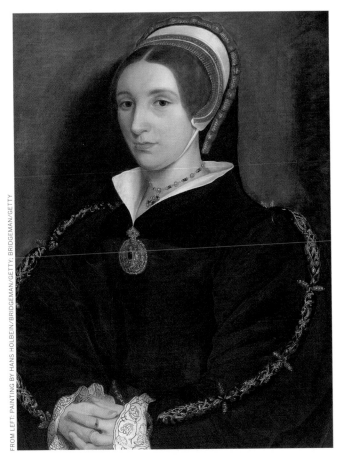

Catherine Howard

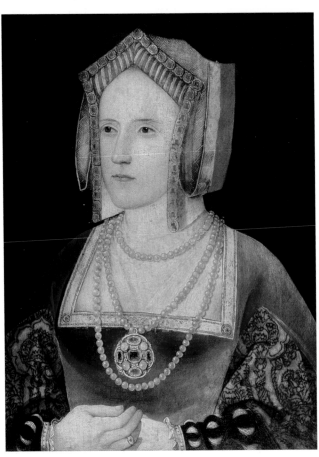

Catherine Parr

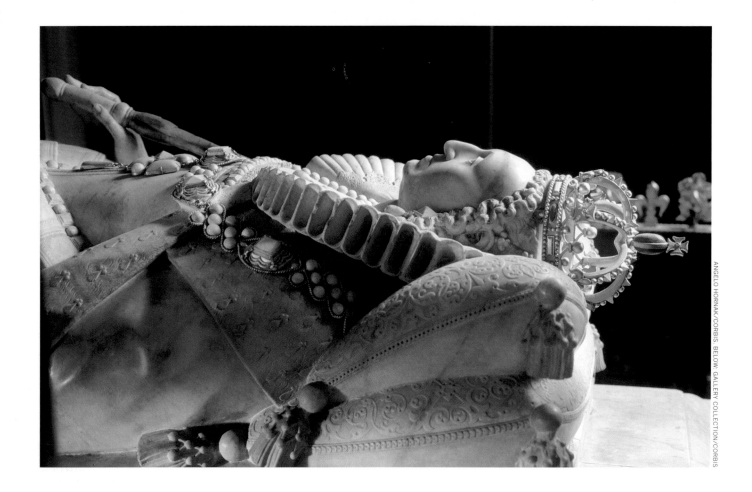

ANGELO HORNAK/CORBIS. BELOW: GALLERY COLLECTION/CORBIS

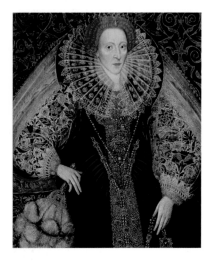

Top: The effigy of Elizabeth I that today rests in Westminster Abbey was ordered promptly by the queen's successor to the throne, James I, and fashioned by the Flemish artist Maximilian Colt, who subsequently became James's Master Carver. The portrait above, made during Elizabeth's lifetime, is attributed to John Bettes the Younger, whose father, also a portraitist, had worked for Elizabeth's father, Henry VIII.

ELIZABETH REGINA

If her father Henry VIII stands as the most famous English monarch, his daughter probably stands tied for second with Victoria—and, indeed, may trump her old man as the most influential. She was certainly among the most effective during her long, 44-year reign. Elizabeth, daughter of Anne Boleyn and Henry, was not groomed for the throne. Indeed, she was declared illegitimate—as child and heir—when her mother was beheaded, two and a half years after giving birth to her. Henry VIII, at the behest of his final wife, Catherine Parr, reached a rapprochement with Elizabeth and her older half sister, Mary, and reinstated them in the line of succession. Edward VI succeeded Henry, then died after having sought to spurn his sisters and hand his crown to Lady Jane Grey, Henry VIII's great-niece. Lady Jane ruled but nine days before Edward's will was declared invalid, and Mary I was crowned, with Elizabeth in attendance. Mary and Elizabeth differed on several issues, most prominently religion: Mary wanted England to realign with Rome, while Elizabeth supported her father's independent course. When Mary died at age 42 in 1558, Elizabeth ascended to the throne and charted her own course.

The Elizabethan Era—what a burgeoning time for England! Culturally, there were Shakespeare and Bacon and Marlowe. Expanding beyond its shores, there was Sir Francis Drake, spreading his aspirant empire's wings. England was becoming a world-beater.

Was Elizabeth the reason? Historians are divided on this question. The Virgin Queen had as a motto, "I see, and say nothing." In spite of this shrewdly cautious approach, she could be adventurous and aggressive. Queen from age 25 until her death in 1603, she always sought, as she stated in 1558, "to direct all my actions by good advice and counsel."

In doing so, she solidified her nation's church, she extended England's reach and power, setting Britannia on the road to empire, and she lent her name to an age.

GEORGE'S (NOT QUITE) UNITED KINGDOM

King George III's tenure was, like Elizabeth's, long: He ruled Great Britain and Ireland from 1760 forward and, after these countries were formally joined in 1801, became the first King of the United Kingdom until his death in 1820—though his final years on the throne saw him debilitated by mental illness. Before George lost his mind, his reign was marked by foreign adventures, most of them of the military kind, in places as near at hand as France and as far flung as Africa, Asia and North America. On this last continent there ensued a protracted conflict, begun on April 19, 1775, the outcome of which would have enormous consequence for not only Great Britain but, as things turned out, the entire world.

There had been disgruntlement in England's American colonies about taxation without representation and other issues when, early on that spring morning, the Shot Heard Round the World was fired in Massachusetts. A year after the Revolutionary War was ignited, the colonies declared that they were now "free and independent states," although that notion could only be confirmed by the outcome of battle. The Declaration of Independence, authored principally by Thomas Jefferson, Benjamin Franklin and John Adams, made a point to indict George III personally: "He has plundered our Seas, ravaged our Coasts, burnt our towns, and destroyed the Lives of our people." In New York, a statue of the king was taken down.

As is the case with Elizabeth's legacy, historians are divided on George's actions and motivations in pursuing the war with his colonies. Some say he was stubbornly committed to beating down the rebels, others say he did what he had to do. In any event, the war dragged on, and Britain did not recognize the independence of America until 1783. Two years thereafter, George III was cordial—amiable, it can be said—in receiving the first American minister to Great Britain, John Adams: "I was the last to consent to the separation; but the separation having been made and having become inevitable, I have always said, as I say now, that I would be the first to meet the friendship of the United States as an independent power."

That friendship continues today, and over the years has done much to define the world order and to preserve freedom and democracy in nations that seek these inalienable rights. If Adams might be surprised by this turn of events, George would surely be amazed.

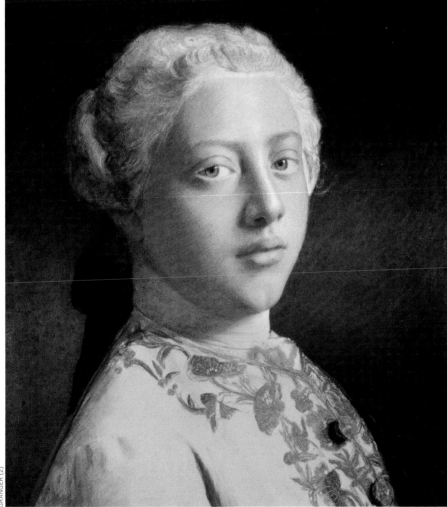

Left: This portrait was made by the prominent French-Swiss painter Jean-Étienne Liotard in 1754, when George was the teenaged Prince of Wales. Below: It is now 31 years later, and much has transpired, crucially including the Revolutionary War in America, when, in 1785, King George (at right) receives John Adams as the first U.S. ambassador to the English court. At this point, the king was perhaps angry but not yet mad. A curious but inconsequential footnote: It has been remarked how closely Britain's King George resembles his nemesis, our own George (that being Washington), in contemporaneous renderings.

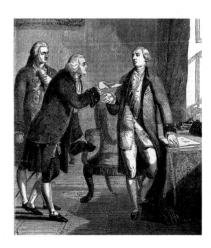

KINGS AND QUEENS OF STAGE AND SCREEN

The regal realm has been catnip for dramatists, not to mention for actors and actresses, ever since the first curtain was raised. On these pages: Palace intrigues down through the years.

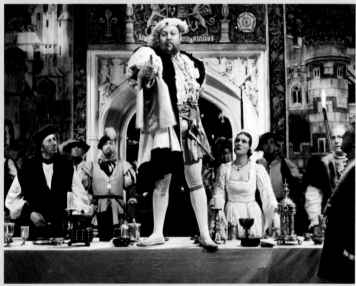

Charles Laughton wins an Oscar for the 1933 film The Private Life of Henry VIII, *which has this tagline: "He Gave His Wives a Pain in the Neck."*

Geneviève Bujold plays one of those wives, Anne Boleyn, in 1969's Anne of the Thousand Days.

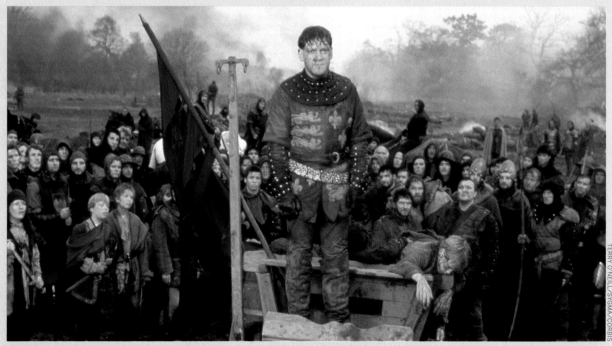

Kenneth Branagh rallies his mighty few in the 1989 big-screen adaptation of Shakespeare's Henry V, *which Branagh also directs.*

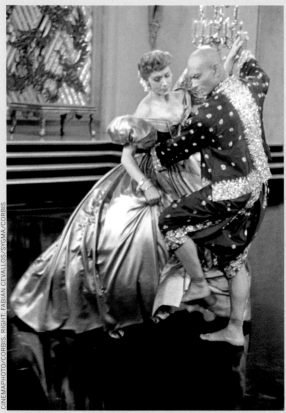

Deborah Kerr and Yul Brynner decide that we shall dance in the 1956 film version of Rodgers and Hammerstein's The King and I.

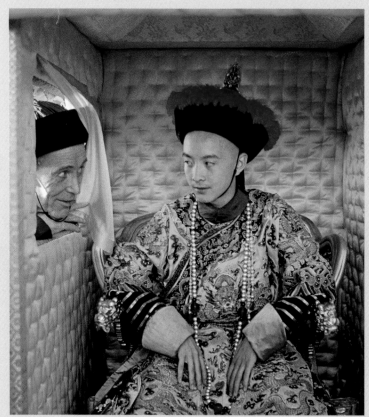

Peter O'Toole counsels Tao Wu, in the role of 15-year-old Pu Yi in 1987's The Last Emperor, *which won Best Picture and, for Bernardo Bertolucci, Best Director Oscars.*

The legendary Soviet director Sergei Eisenstein couldn't tell his story Ivan the Terrible *in one movie so he made two; this still is from 1944's* Part One.

Ruggero Raimondi plays the title role in another film about Russian aristocracy, Boris Godounov, *a 1989 adaptation of the Mussorgsky opera.*

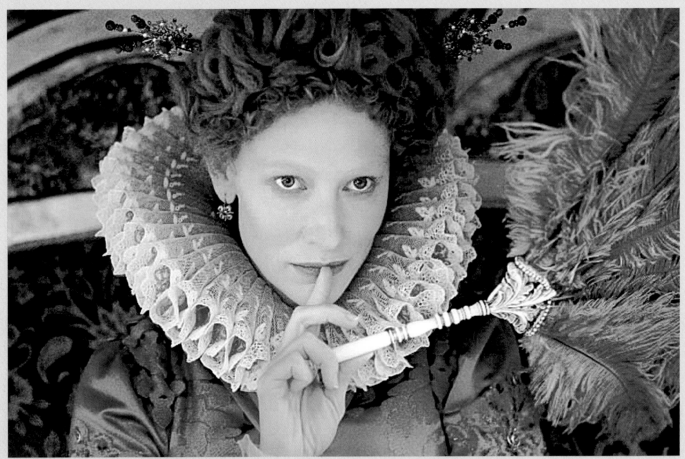

The Australian Cate Blanchett—technically a subject of the Commonwealth of Nations having Elizabeth II as its monarch—is twice nominated for Best Actress for portraying Elizabeth I, in the films Elizabeth *(1998) and, here,* Elizabeth: The Golden Age *(2007).*

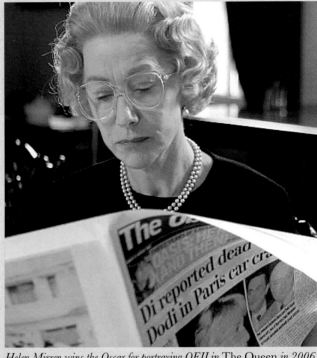

Helen Mirren wins the Oscar for portraying QEII in The Queen *in 2006. Bizarrely, that same year she wins the Emmy for playing QEI on television.*

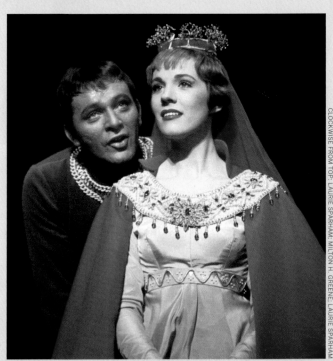

Richard Burton, playing King Arthur, turns Julie Andrews's head in 1960 during the Broadway run of the musical Camelot.

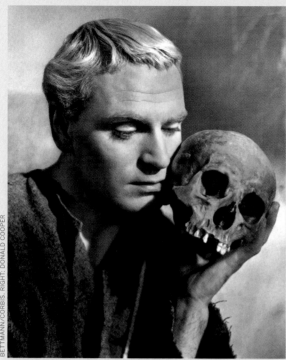

Alas, Laurence Olivier knows poor Yorick well—and knows how to play and direct Shakespeare's Hamlet *very well in his classic 1948 film version. The film wins Best Picture; Larry, Best Actor.*

Nigel Hawthorne wins the 1992 Olivier Award, given to the best actor on the London stage that year, for forcefully conveying The Madness of George III.

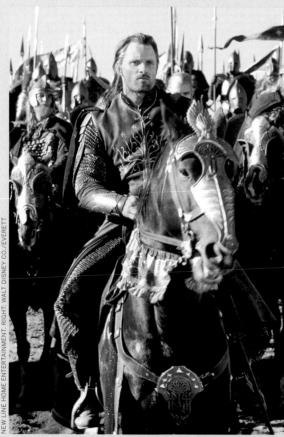

Viggo Mortensen closes in on his fate in the 2003 film The Lord of the Rings: The Return of the King.

In 1950, Walt Disney brings Prince Charming and Cinderella majestically and romantically to the big screen.

The
WINDSORS

*Many throughout the world are aware
that today's royal family in Great
Britain consists of members of "the
House of Windsor," but might
not be able to satisfactorily explain what
that is. Put most simply, these people
are the direct descendants of the long-
reigning and legendary 19th century
queen, Victoria, seen opposite. She in fact
never knew herself as "a Windsor."
As we shall learn, that name was
adopted well after her death for
political reasons. It's all very compli-
cated, fascinating—and totally fun.*

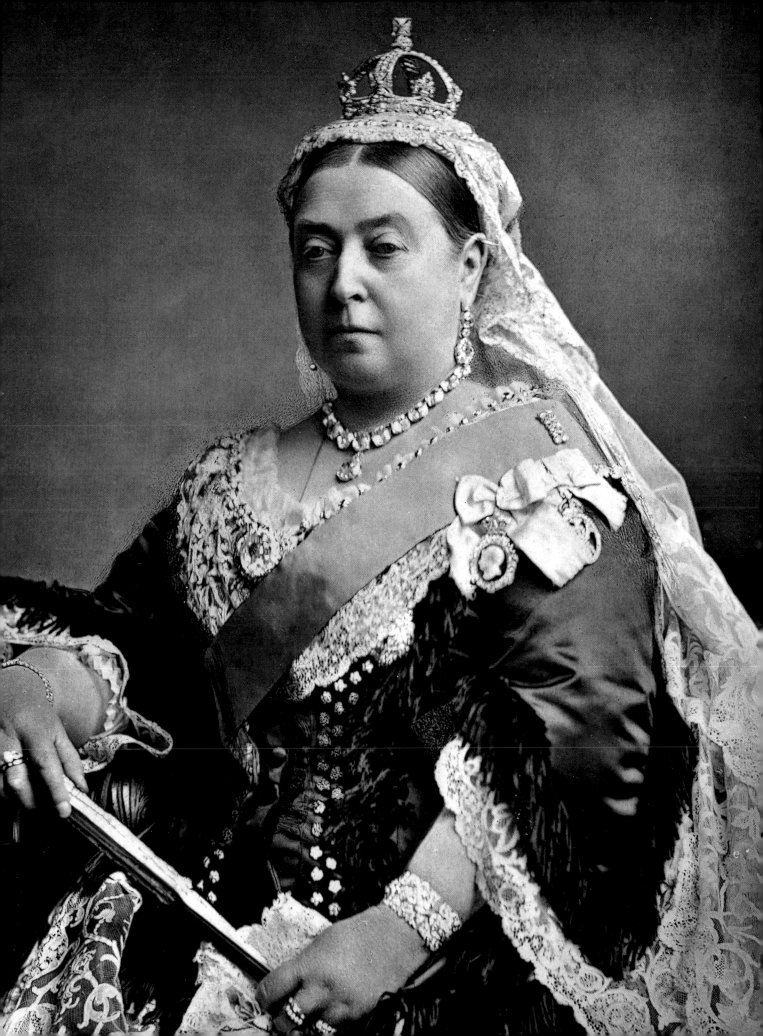

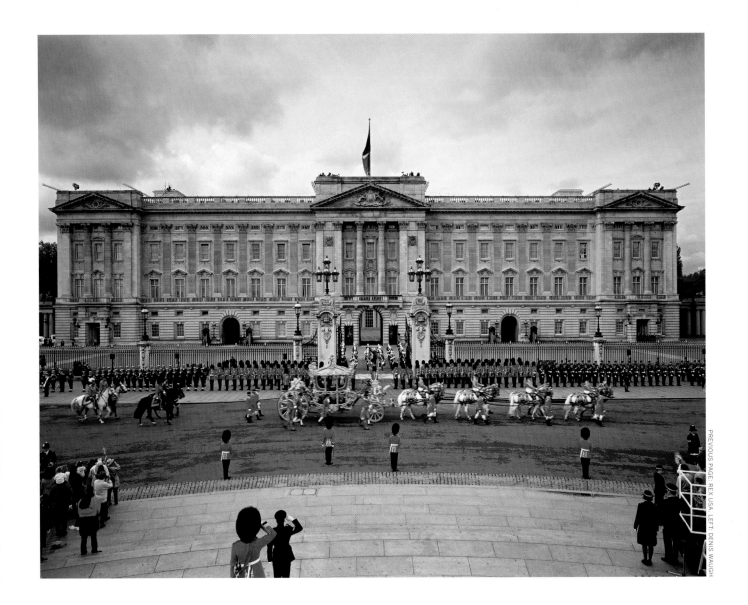

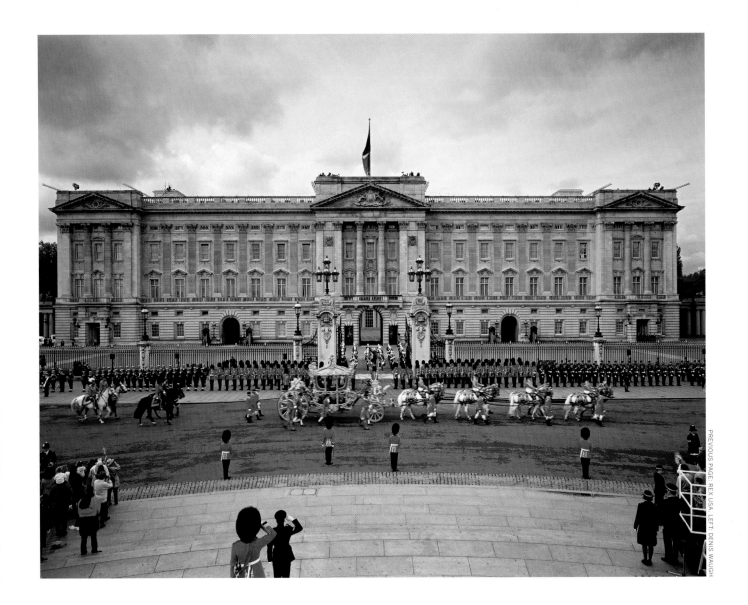

WHAT COULD BE MORE BRITISH THAN A WINDSOR?

The House of Windsor is actually less than a century old, though the lineage of the family claiming this name extends further back. The champion monarch to go under the banner of the Windsors is unquestionably Queen Elizabeth II. She still sits upon the throne, as she has since 1952. Her majestic coronation, on June 2, 1953, is commemorated in our book beginning on page 58. In the photograph above she is saluted by Beefeaters, guards and the massive British citizenry—technically, her subjects—as she sits in her gilded coach outside Buckingham Palace on June 4, 2002, on her way to celebrations marking the golden jubilee of her accession to the throne.

The answer to the question posed by our headline might surprise you, for it is: many, many things. And many, many people. The name *Windsor*, which is today applied to the numerous descendants of Queen Victoria and Prince Albert, might be said to be a *nom de convenience*, even a *nom de necessity*. We shall explain.

Victoria, who ascended to the throne in 1837 to begin a 63-year reign (the longest to date of any British monarch), and who would be the last ruler of the House of Hanover, was the granddaughter of George III and the niece of King William IV, who immediately preceded her as British sovereign. So she was a quite proper claimant. However, she was of mostly German descent; her father was Prince Edward, Duke of Kent and Strathearn, and her mother was Princess Victoria of Saxe-Coburg-Saalfeld. She married Prince Albert of Saxe-Coburg and Gotha, son of the German Duke Ernst I, and that only made matters more Germanic. Which was all well and good for a while. Victoria wanted her son, when and if he ever did get to succeed her, to rule as a representative of the House of Wettin,

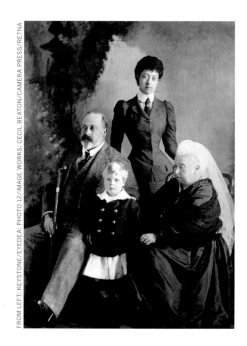

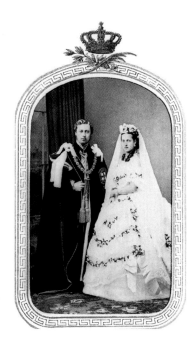

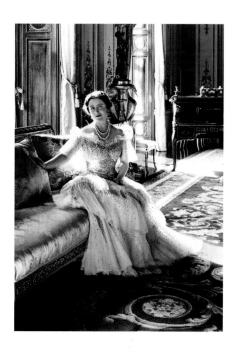

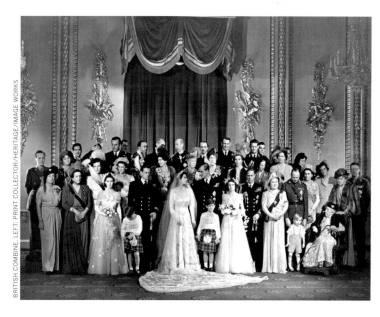

a thousand-year-old German family of which Saxe-Coburg was a branch. This, she felt, would properly celebrate England and Germany's shared Saxon heritage. Edward VII did indeed reign as a member of Saxe-Coburg and Gotha, as did his son George V. But then, with the advent of World War I, Brits began to feel none too chipper about all things Germanic. They took particular umbrage at the surname Gotha, as one of the enemy's most effective heavy aircraft was the Gotha G.IV, which was capable of crossing the English Channel and dropping bombs on London. On July 17, 1917, George V made a masterful PR move, as kings are allowed to do, when he declared, "Now, therefore, We out of Our Royal Will and Authority, do hereby declare and announce that from the date of this Our Royal Proclamation Our House and Family shall be styled and known as the House and Family of Windsor, and that all the descendants in the male line of Our said Grandmother Queen Victoria who are subjects of these Realms, other than female descendants who may marry or may have married, shall bear the said Name of Windsor."

Windsor was, of course, veddy, veddy British, what with the town in Berkshire and the royal castle situated there. Now it was even more British. Even if the actual family members, blood being thicker than decrees, were not.

Same family, different "houses." Top row, from left: In 1896, young Edward, Prince of Wales, his grandparents and great-grandmother Victoria were still of the house of Saxe-Coburg and Gotha, as the future King Edward VII had been when he wed Alexandra of Denmark at, of all places, Windsor Castle in 1863; but by 1939, when Queen Elizabeth posed for Cecil Beaton in Buckingham Palace, the royal family were Windsors. Bottom row: The impetus for the name change was Anglo-German animosity during World War I, and at left we see the now-grown Edward, Prince of Wales, who would briefly reign as King Edward VIII in 1936, serving in that war. One who was born a Windsor is the elder daughter of George VI and the Queen Mum, Elizabeth II, seen at her wedding in 1947.

VICTORIA, POWERLESS YET POTENT

Herman's Hermits had a rollicking good time of it with that hit song about Henry VIII (page 23), and their Brit rock confreres the Kinks, more caustic by a mile (and by the way, a much better band), paid homage (sort of) to a later, equally legendary monarch. The band's leader, the brilliant Ray Davies, wrote the song "Victoria" as part of his 1969 concept album *Arthur (Or the Decline and Fall of the British Empire)*; it's remarkable how accurately a little pop ditty summed up in a couple of rollicking minutes the many presumptions, hypocrisies and outright cruelties of a decades-long societal epoch.

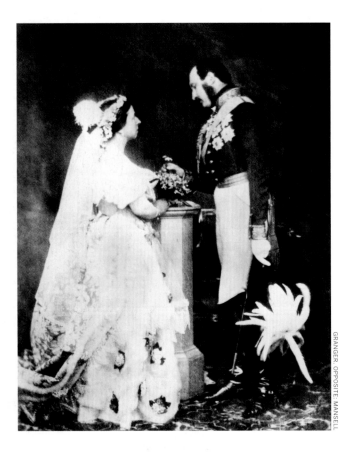

GRANGER. OPPOSITE: MANSELL

Written from the perspective of a deluded commoner, one who had drunk way too much of the palace's Kool-Aid, the lyrics warmly remembered a time when everyone realized that sex was evil; that England quite properly ruled the world; that the wealthy lived in a society apart; and that it was the happy duty of the lower class to grow and fight, perhaps to die, for the mother country. In this land of "croquet lawns, village greens/ Victoria was my queen." The singer is content about that; he trusts her implicitly: "From the rich to the poor/ Victoria loved them all."

Whether Victoria indeed loved even most of them has been debated and often derided in the histories, but she influenced them all for a long, long time, even though she was essentially without real power, and prime ministers like Disraeli and Gladstone ran the show. She quarreled with her ministers at the outset of her reign, trying to assert herself, but soon realized that in a constitutional monarchy, she was meant to sit, serve, be seen and set an example.

She gave her name to an epoch that not only saw Great Britain rise to global domination yet unseen in world history—a reach far exceeding that of Alexander the Great, Genghis Khan or Napoleon—but produced individual genius after genius, from the aforementioned political leaders to scientists such as Charles Darwin and writers such as Charles Dickens and Elizabeth Barrett Browning. Did Victoria have anything to do with this? Probably not much, but, as assigned, she did set an example. She clearly espoused a moral code (a repressive one, which would find its rebellion in such stark and notorious episodes as the rampage of Jack the Ripper). She came to represent a stiff-upper-lip "Britishness" that endures to the present day. She married well and mourned her late husband effusively. Perhaps not a lovable person at bottom, she came to be beloved.

The Victorian Era. It is more about a time and place and a national aggressiveness and overarching sense of aspiration and invention than it is about a woman.

But there *was* a woman: "Croquet lawns, village greens/ Victoria was my queen."

So many marriages between royals, particularly royals from separate nations, have been made in the interests of convenience or politics. That of Victoria and Albert, recorded above, left by the legendary photographer Roger Fenton in 1854 (it's like an American couple of the same time having Mathew Brady shoot their wedding), was a true love match. After Albert's death and until the day she died many decades later, Victoria wore black in public, as she does opposite, on horseback at Balmoral Castle in 1869. A gossipy postscript, however: The man in the kilt is John Brown, who was her attentive attendant for so many years that Fleet Street tongues did wag, even in the laced-up Victorian Era.

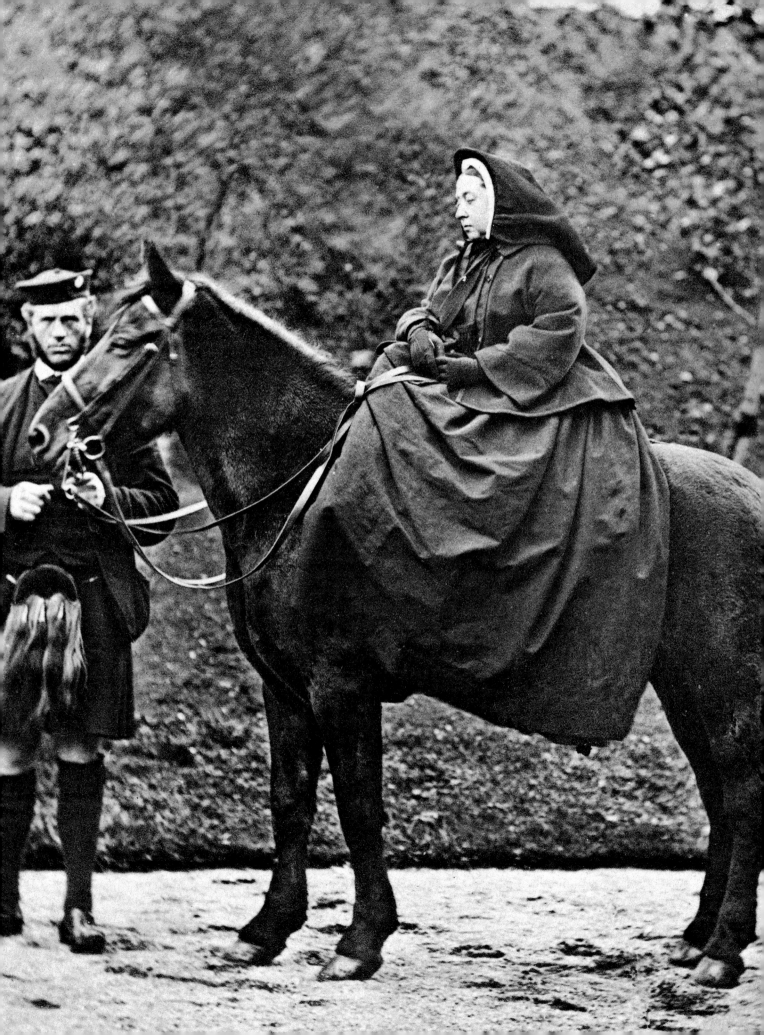

There's a whole lot of royalty going on in this family portrait. Of course that is Queen Victoria in the center, where she belongs. The man in white on her right-hand side is destined to become King George V. The future King George VI is the child third from the left, on his mother's knee. The other baby being dandled on a knee, fifth from left overall, will also become a king: Edward VIII. So we have four current and future monarchs in one sitting: pretty impressive. For those royals watchers in our readership who care, presented here in a "Where's Waldo" fashion are also Queen Mary (who will become the Queen Mother during George VI's reign and then, briefly, the Dowager Queen Mary in the first year of Elizabeth II's); the Duchess of Connaught; Prince Arthur; and Princesses Patricia, Marie Louise and Beatrice. When the family gathers for a picnic, everyone brings a title. Or two or three.

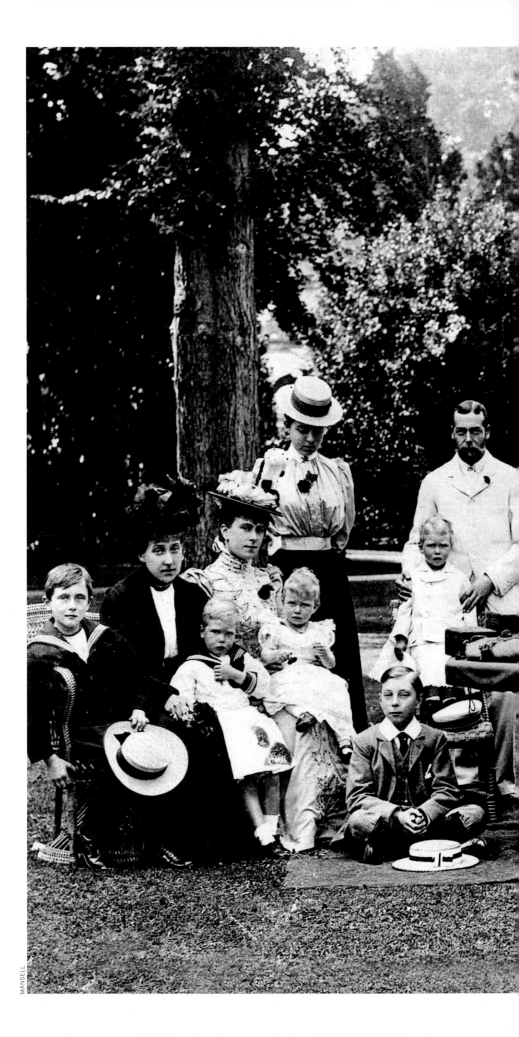

MANSELL

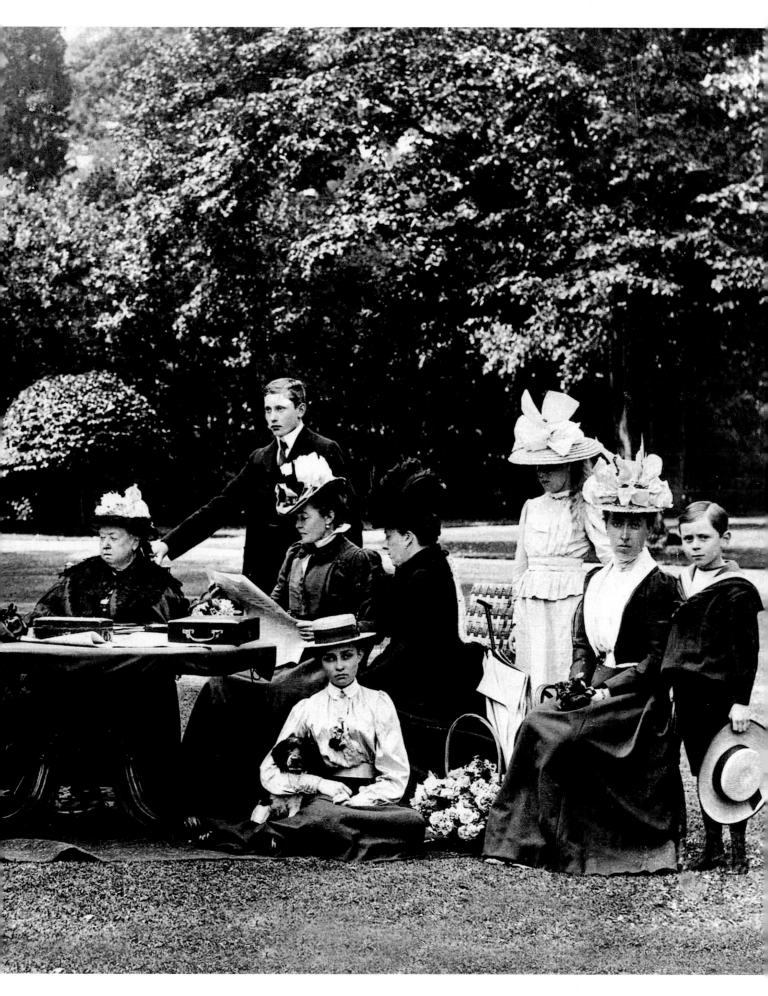

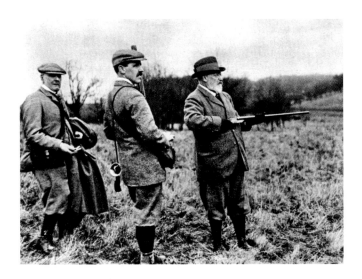

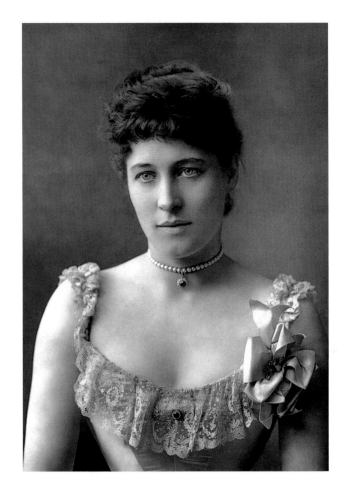

Before becoming King Edward VII, Queen Victoria's eldest son was the longest-serving heir apparent in British history. Still, he enjoyed nearly a decade as king from 1901 to 1910, presiding over a time of peace, prosperity and continued economic and industrial growth known now as the Edwardian Era. He did all the royal things: He hunted birds (above); married well, to Alexandra of Denmark; enjoyed dalliances on the side, including an infamous affair with British actress Lillie Langtry (right); and then died regally (below, "his last sleep" at Buckingham Palace) and was deeply mourned.

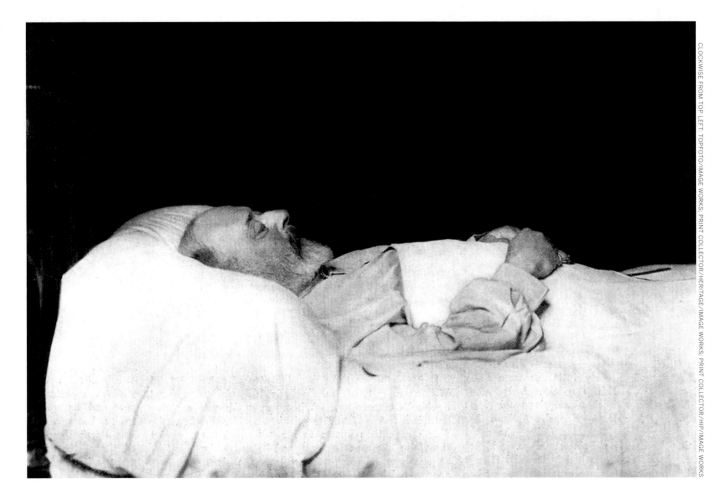

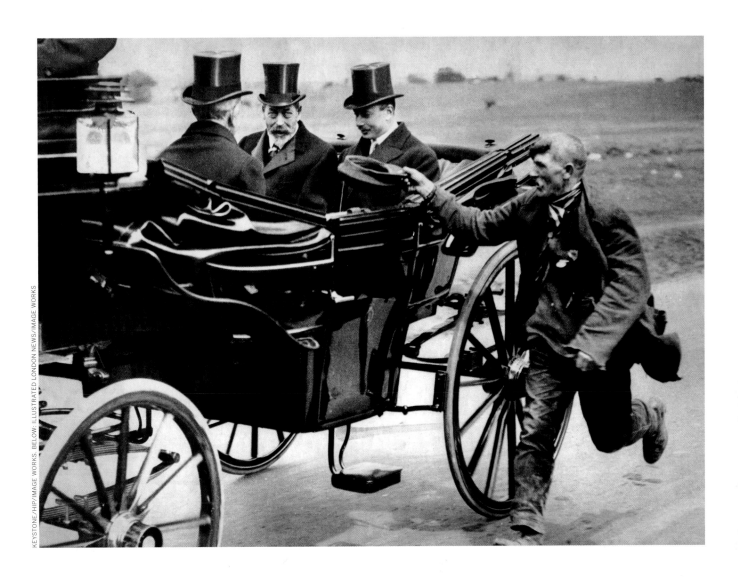

Edward's son George, who would succeed him as George V, was suited like his father for a Victorian or an Edwardian time, but that's not what the world would offer. He was a man of stamp collecting and game hunting, but socialism was on the rise—communism and fascism too—during his relatively long reign from 1910 to 1936. Meantime, the Great War ensued, the Great Depression hit, and the world was altered mightily. During World War I, he was the one who was compelled to shed his family's Germanic name (Saxe-Coburg and Gotha) and adopt a British-sounding one (Windsor). He coped as he could, but when he died, his country—and the world—was on the verge of an Armageddon like no other. Scenes from a regime: A beggar holds out his cap as George's carriage passes (above), and the king at the helm of the royal yacht Britannia on a recreational cruise (right).

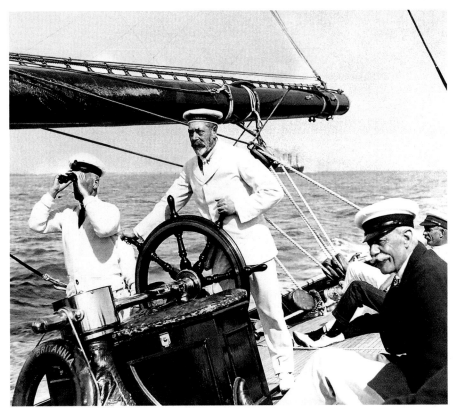

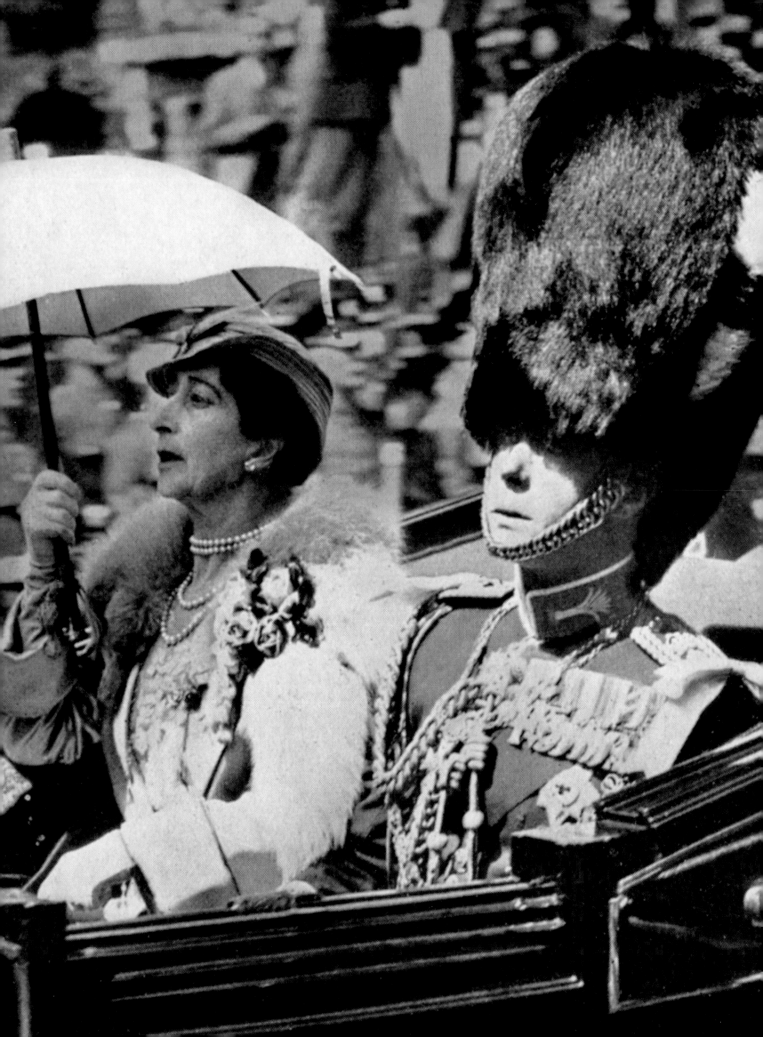

SCANDAL! ABDICATION!! *HORRORS*!!!

It could be that much of the English-speaking world, especially the large segment sequestered in the United States, didn't know what the word *abdicate* meant before 1936. That was the year that staid George V and Queen Mary's elder and instinctively rebellious son—who was involved with one Wallis Warfield Simpson, an American divorcée—found his way to the throne as the Windsor king Edward VIII. This is the point in our book where "world history" meets "the tabloids"—where shenanigans take on the kind of BANNER HEADLINE and photoready currency that would land them on the front page of not just the Fleet Street tabs but even on the cover of, for instance, the august American weekly magazine LIFE. Oh, yes: We paid close attention to the royals. And since we arrived on the scene in 1936, as did Edward and Wallis, our relationship with the royals was—as perhaps their own was—a marriage made in heaven.

Many of the pictures on the pages that follow, right through to the end of our book, were first seen in the United States in LIFE. We would cover the tumult that followed Edward's abdication; the exemplary behavior of his successor, George, during the London Blitz; the marriage and, of course, the coronation of George's daughter Elizabeth; her long and continuing career as queen; the wacky decades-long procession of the Queen Mum's increasingly egregious hats; the courtship and outsize wedding ceremony of Di and Charles; the fab Fergie sideshow; the tragic death of a princess—all of it. In this book we even look at what everyone senses will be the next royal marriage. What's up, William and Kate?

But to return to where we were: What a launch to this parade of pomp and pageantry and altogether print-worthy activity was the scintillating affair of the king and Mrs. Simpson!

Edward Albert Christian George Andrew Patrick David, Prince of Wales, became king on January 20, 1936, following the death of his father. Almost as soon as he took his seat on the throne, there were concerns. He was modern in a way that his immediate predecessors had not been. He seemed at once more charismatic and less stoic than his father, and it was unclear whether this was a good thing or a bad one. It was widely held that his sequential associations with older women were worrisome and might lead to no good end. Depending upon your point of view—love conquers all versus the preservation of monarchy—that's precisely where they did lead. Mrs. Simpson simply would not be accepted as queen by the British people, and this became clear as the months rolled by in '36 and her relationship with the king became clear; the prime minister himself was prepared to step down. Rather than cause a constitutional crisis, Edward abdicated, and on December 11, 40 days shy of even a year as king, one of the shortest reigns in British history came to an end. His brother George, the new monarch, made him Duke of Windsor, and with that title, and with the former Mrs. Simpson at his side, he would live out his days.

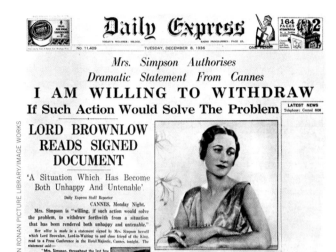

The trials of Edward: furry hats, affairs of the heart, the question of abdication. The photo on the opposite page shows Queen Maud of Norway and Edward, Prince of Wales, returning to Buckingham Palace during King George V's silver jubilee celebrations in 1935. After 25 years on the throne, the king does not have much longer to live, and the following January Edward will succeed him as King Edward VIII. Edward's reign will last less than a year and stands today among the shortest in the history of the monarchy. The newspaper headline above, from December 8, 1936, reports Wallis Simpson's gracious offer to step aside in order to write closure to "a situation which has become both unhappy and untenable." But Edward will not hear of it, and only three days later tells the nation in a radio broadcast (below) that he is quitting as king in response to the demands of true love. As the photographs on the next two pages indicate: Though Edward would be out of the palace, he would never be out of the picture.

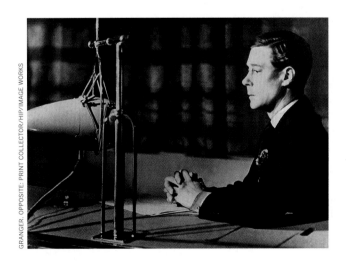

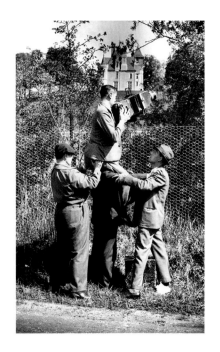

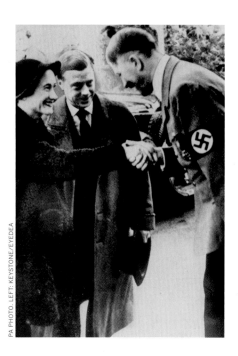

PA PHOTO. LEFT: KEYSTONE/EYEDEA

The world learned soon enough: You just can't keep the Duke and Duchess of Windsor down. Certainly the paparazzi weren't going to let go of this story just because the guy wasn't king anymore, and at far left we see, on June 3, 1937, three members of that noble tribe staking out a position at the fence surrounding Château de Candé, a castle near Tours, France, where, inside, Edward and Wallis are exchanging vows. Four months later the gadabout couple are breezing through Munich, Germany, where they exchange bons mots with Adolf Hitler (left); the Nazis were hardly uncontroversial at that time, and the behavior of such as the Windsors and British Prime Minister Neville Chamberlain, which certainly looked like appeasement, drew fire back home. In America, the duke and duchess were treated as A-list celebrities. The duke could draw the attention of LIFE magazine by touring the agricultural precincts of Pennsylvania (bottom, left) or posing with his wife for the June 9, 1941, cover (below). Opposite: When the famous photographer Philippe Halsman asked the Windsors to jump for his lens, they hopped to it.

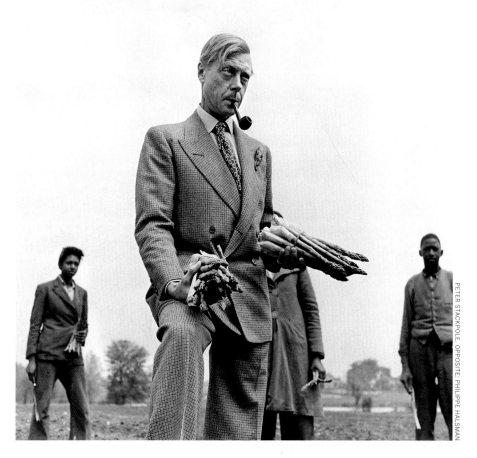

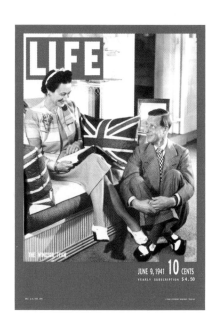

PETER STACKPOLE. OPPOSITE: PHILIPPE HALSMAN

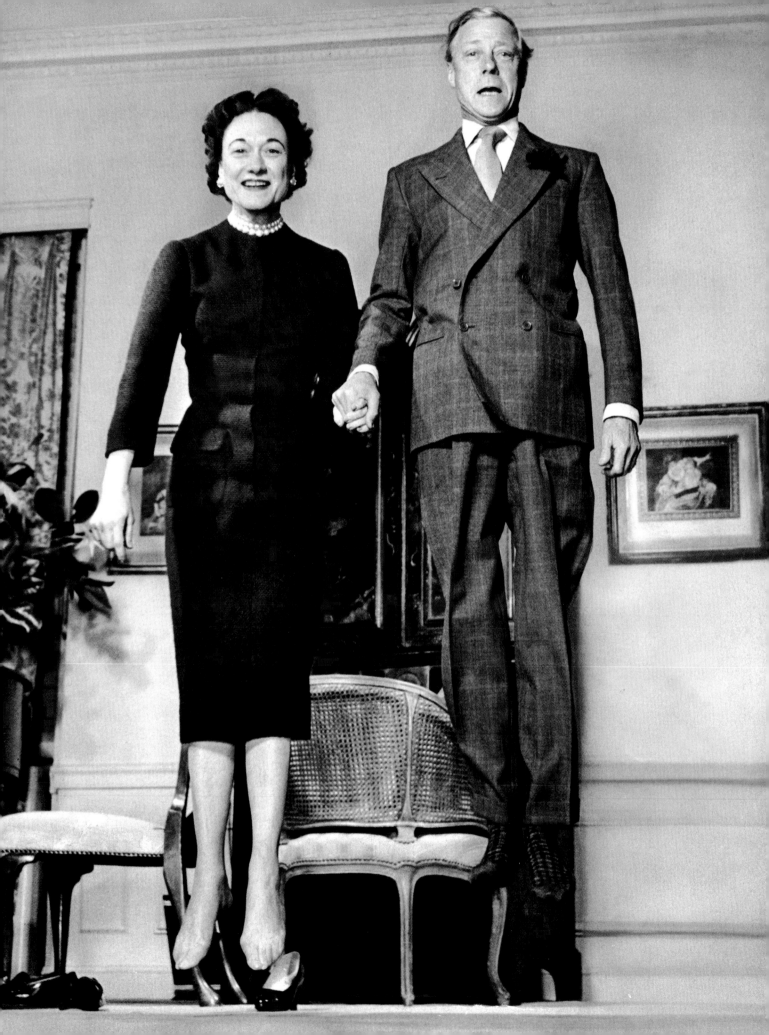

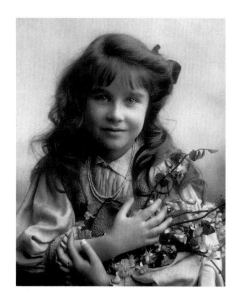

Seven-year-old Elizabeth Bowes-Lyon, above, would grow to become Queen Elizabeth and then "the Queen Mum," famous worldwide as the sweet, hat-wearing mother of Elizabeth II. The lad in the picture below, taken in the late 1890s, is Albert Frederick Arthur George, the second oldest son of King George V, who would wed Elizabeth in 1923, become the father of Princesses Elizabeth and Margaret, and ascend to the throne upon his brother Edward's abdication in 1936. George VI became the third king from the House of Windsor (the renamed House of Saxe-Coburg and Gotha). He would die at 56, cigarettes a culprit, but his reign would be eventful, as England would, not long after his coronation, be at war with Germany. Opposite: He is in the forward jeep and his wife is in the trailing one as they tour a venue where mock battles are waged to prepare the troops.

THE RIGHT STUFF

It has been alleged by some historians that two of the most astute self-mythologizers among the 20th century British royals were Lady Elizabeth Bowes-Lyon and Lady Diana Spencer. If the accusation is accurate, then their talents were deep indeed, for the former went on to become the wildly beloved Queen Mum and the latter grew to be the equally revered Princess Di—and both remain warmly remembered today, not only in their native land but throughout the world. The indictment against Bowes-Lyon is that, as a young woman, she clearly aspired to be the Queen of England one day and that she set her sights on Edward, the Prince of Wales, only to be spurned by him, whereupon she settled for his kid brother Albert, the Duke of York. If this is so, then fate smiled broadly on Elizabeth when Wallis Simpson entered the picture and King Edward VIII exited the frame by abdicating and handing the crown to Albert, who became George VI. It needs be said in Elizabeth's defense: As the behavior already recounted in our book plainly indicates, there are far, far worse things than naked ambition as it is pursued through proper societal rules of play. If Bowes-Lyon wanted to be queen—well, what girl doesn't? Once she *was* queen, she and her fine husband were as good a king and queen as Merrie Olde England has ever been blessed with. This judgment includes, by the way, Elizabeths I and II.

First, they were, by accounts, loving parents, and they raised smart and talented daughters, Elizabeth (still with us, of course, as Queen Elizabeth II) and Margaret, who died in 2002. Second and more important, they led, they actually *led,* and in doing so probably preserved the monarchy.

The reception of George VI and his wife as king and queen by the British people in 1936 was as rapturous as it was desperate. After the Edward-Wallis scandal, and with the full realization that England wasn't ruled by a king anyway and that this "royals" thing had become something of a tawdry and expensive charade, there was a real probability that the ancient order would come to an end, would be dismissed with prejudice, would be dismantled entirely.

But then the war began, and England was attacked directly by Axis forces. The king and queen proved as inspiring a rallying point as Prime Minister Winston Churchill himself. They refused to leave London for the relative safety of the countryside during the Blitz, and they walked in the bombed-out streets to lift spirits.

For many months before the United States became an active participant in the war effort after Pearl Harbor was attacked in December 1941, it seemed Great Britain might be doomed—but George, Elizabeth and Winston would not allow the people to believe it.

George VI died young (at age 56) in 1952, the victim of far too much smoking. His older daughter would succeed him. By then, Great Britain had emerged from the chaos. And so had the monarchy.

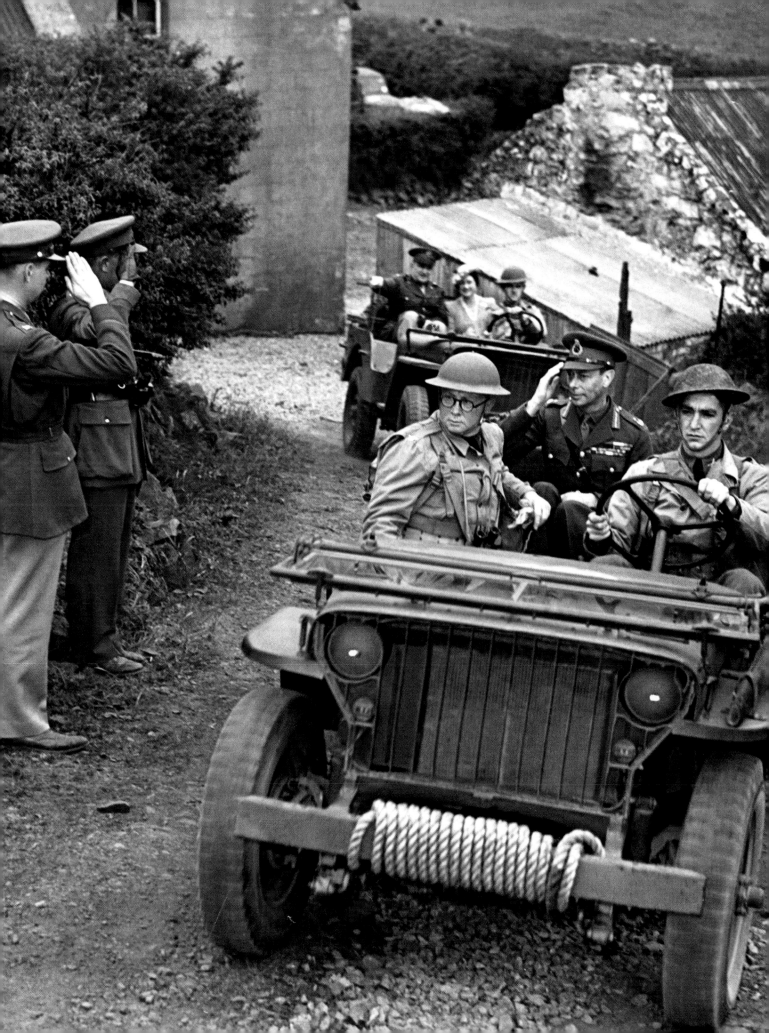

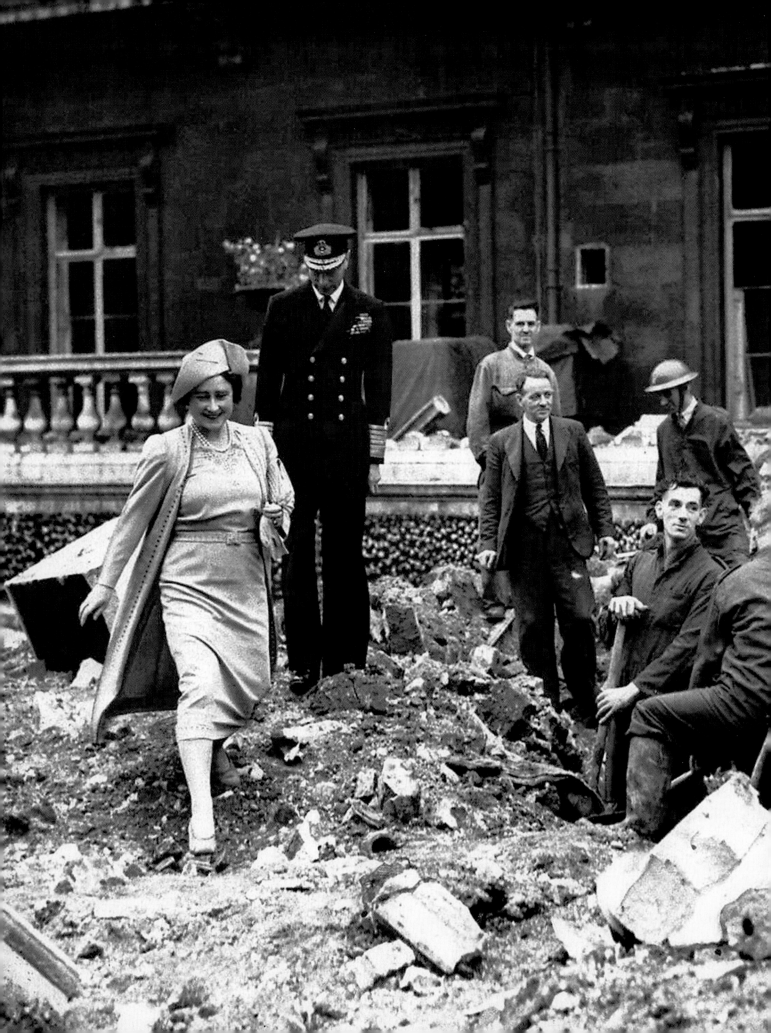

The king and queen's actions during the war stand as a high point in the history of the British monarchy. The Blitz began on September 7, 1940; more than 400 Londoners were killed, many of them in the working-class East End. Left: Four days later, Queen Elizabeth, with King George just behind her, inspects damage at Buckingham Palace inflicted by the Nazi air raids. Two days after this, German bombs destroyed the palace's chapel while the king and queen were in residence; they narrowly avoided death. "I am glad we have been bombed," said the queen. "Now we can look the East End in the face." Indeed, the wartime connection between these monarchs and their subjects was intense and intimate. It was also crucial, since what England needed most, particularly in the days before Pearl Harbor brought the United States fully into the war, was strength of spirit. Publicly, the information was that the royal family would not leave London in the face of the Axis assault, although the two daughters were removed to Windsor Castle and, indeed, George and Elizabeth spent most nights there. But the family adhered to the rationing of food, energy and bathwater along with the general citizenry. Eleanor Roosevelt, for one, noted this admiringly after a state visit to the boarded-up Buckingham Palace. George and Elizabeth developed a close relationship with the U.S. President and Mrs. Roosevelt, which certainly did not hurt when Prime Minister Winston Churchill was energetically lobbying FDR to formally enter the fray. As for the bond between the king and the PM: Although Queen Victoria's relationships with her ministers were legendarily strong and influential, history regards that of King George and Churchill as the most important since the palace began answering to Westminster. Although George would not, in fact, have chosen Churchill as Neville Chamberlain's successor in 1940, he quickly realized that Great Britain had been delivered the right leader at the right time, and they conferred weekly during the war. These were indispensable men. And for George, Elizabeth was the indispensable partner.

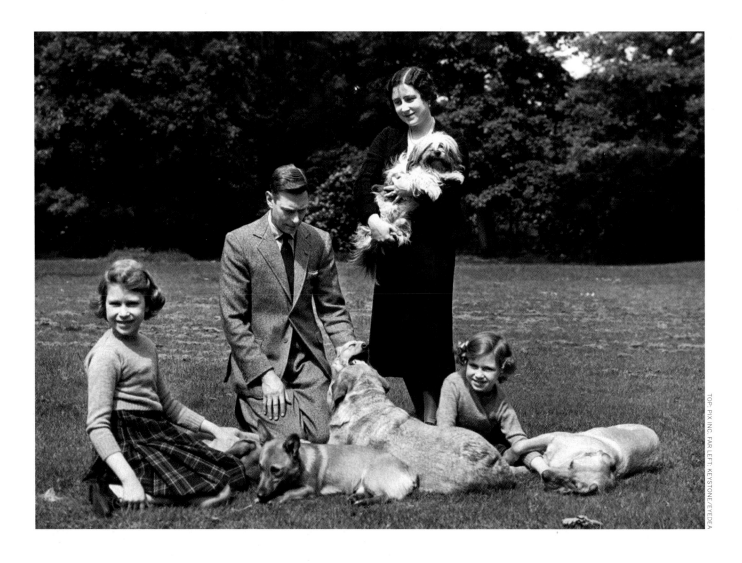

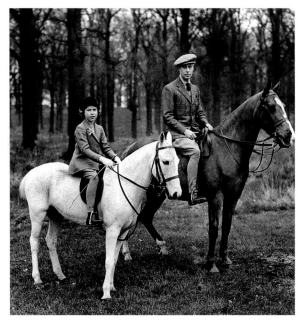

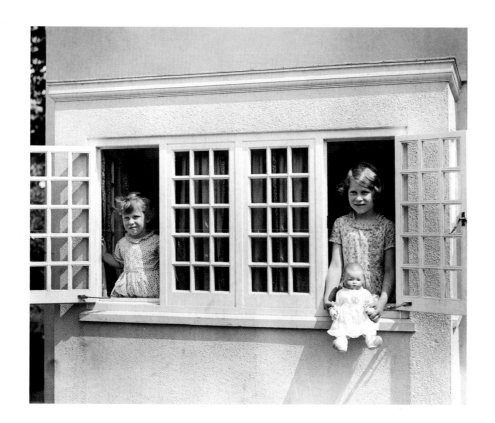

As has been emphasized, the war and its outcome would be the signature of George VI's reign, much as it would represent the ultimate triumph of Winston Churchill's long and constantly episodic military and political career. Meantime, however, there was a family for George and Elizabeth to raise, and by all accounts they were attentive and caring parents—never an expectation when dealing with royals. On the opposite page, counterclockwise from top: In 1936, the Duke of York (months away from becoming king) and his family (Elizabeth at left, Margaret at right) frolic with their dogs, Scrummy, Mimsy, Dookie, Jane and, held by Mum, Choo-Choo; Elizabeth goes riding with her father that same year; and, in 1942, Queen Elizabeth inspects Margaret's Cinderella costume (at left) and Elizabeth's get-up as Prince Charming before the children perform in a play to aid the Royal Household Comforts Wool Fund. Left: The princesses in 1937, their first year in Buckingham Palace. Below is the great moment on May 8, 1945: Elizabeth; her mother, Elizabeth; Churchill; George; and Margaret hail their countrymen upon Germany's defeat. They had played their parts wonderfully well.

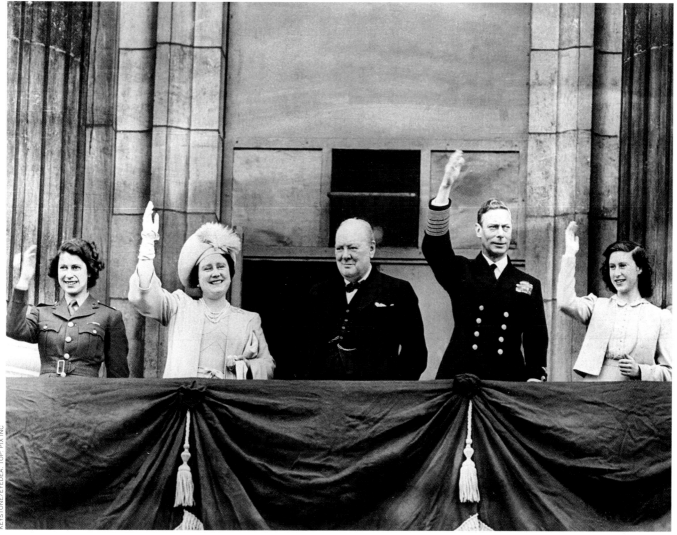

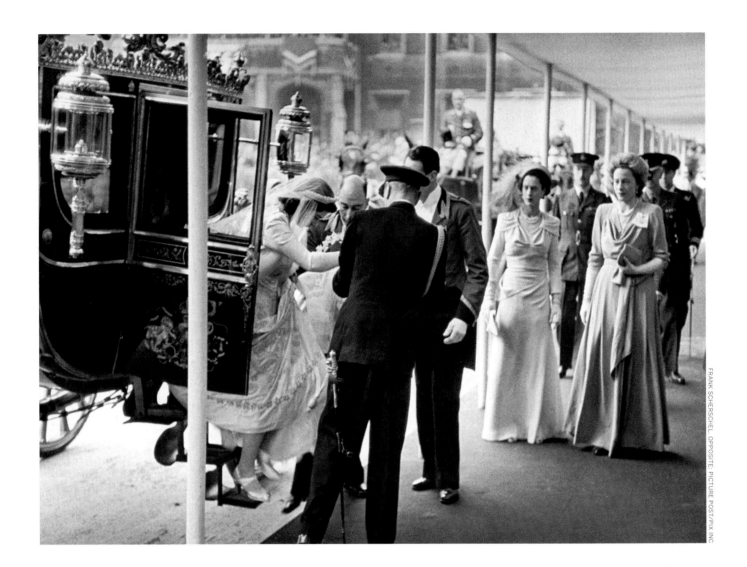

FRANK SCHERSCHEL. OPPOSITE: PICTURE POST/PIX INC.

As we have seen in our day with the joyful attention paid to the relationship and prospects of Prince Will and his beloved Kate, the global public adores a royal wedding. The marriage of Prince Charles and Lady Diana Spencer in 1981 was heralded as "the wedding of the century." That of Charles's mother-to-be in 1947, Princess (destined to be Queen) Elizabeth, and her beau, Philip, was only slightly less splendiferous than Charles and Di's spectacle. Elizabeth first met Prince Philip of Greece in 1939, when she was 13; she swooned on the spot. He popped the question during a stroll at Balmoral in 1946, and as Elizabeth later remembered, "It was wonderful, magical. I just threw my arms round his neck and kissed him as he held me to him, my feet off the ground." Her parents were less rapturous, and it wasn't until the following spring that King George VI grudgingly gave his blessing. Philip was hastily anglicized: He gave up his Greek title and citizenship and was granted the surname Mountbatten and the title Duke of Edinburgh. The wedding took place on November 20 in Westminster Abbey, and then 150 guests repaired to Buckingham Palace for continuing festivities. Elizabeth was radiant in a white satin dress with garlands of pearl orange blossom, syringa, jasmine and the White Rose of York. Winston Churchill proclaimed this first postwar royal celebration a "bright ray of color on the hard gray road we have to travel."

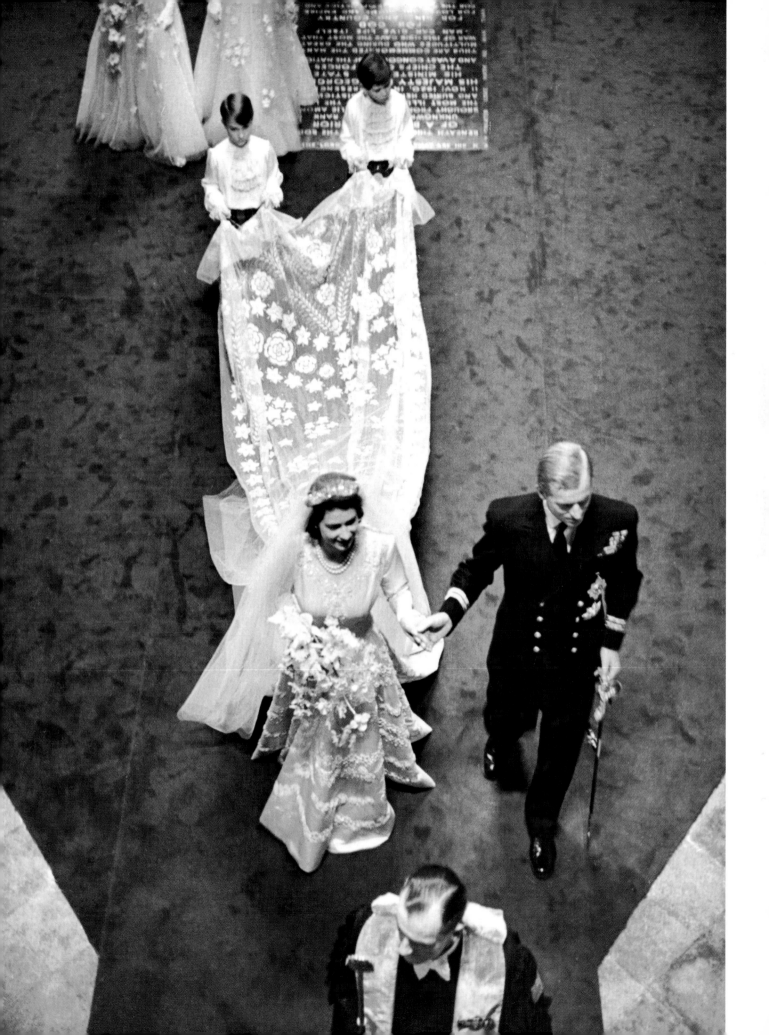

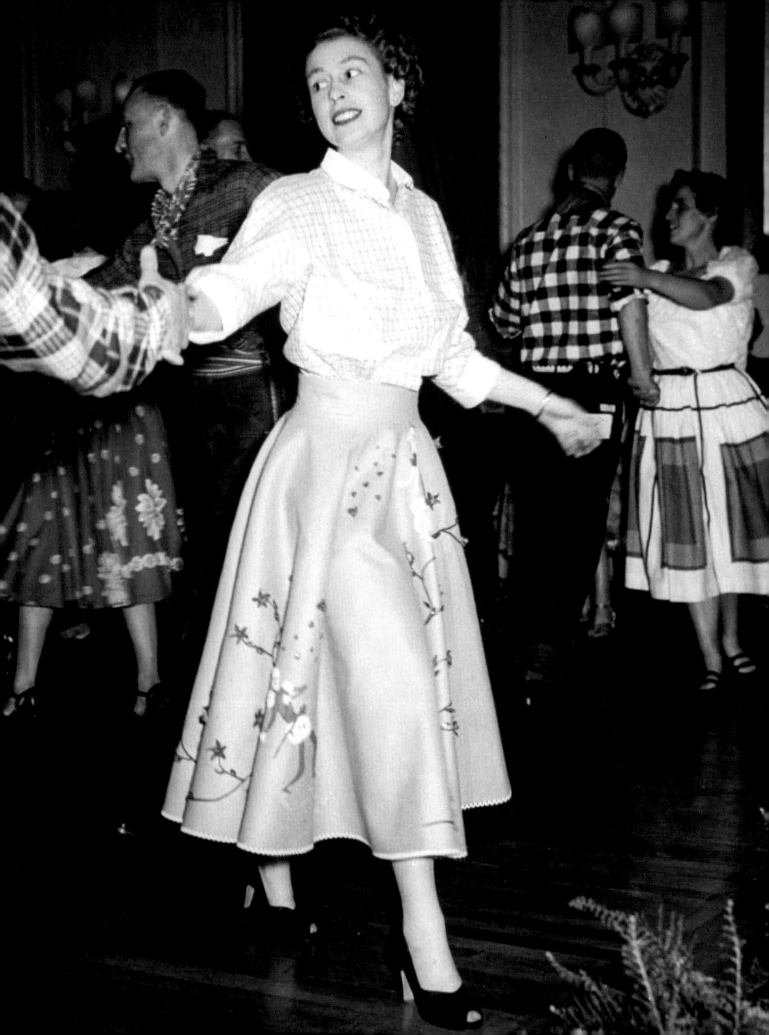

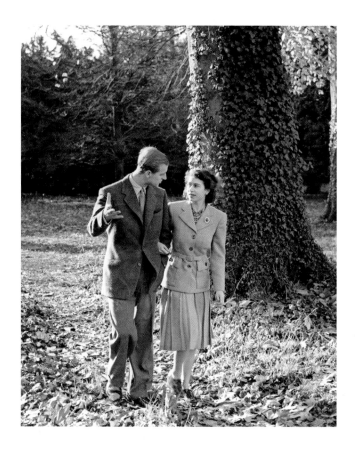

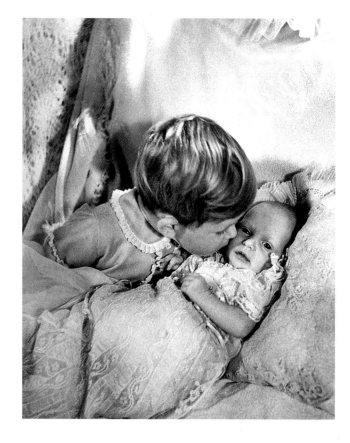

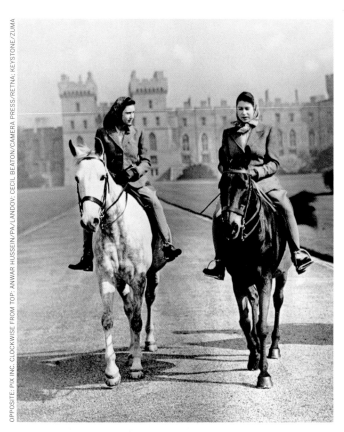

Much of a royal's life involves dressing up and presiding at official functions; it's a life steeped in formality and protocol. When we picture a king or queen, prince or princess in our mind's eye, there is often a crown or tiara for headwear, lots of fantastic jewelry for the women and badges and epaulets for the men, and there is the gracious wave of the hand. Among the royal's subjects in these conjured images, there is often obeisance being paid, even unto kneeling. But royals are real people, too; they have their offstage moments and sometimes let their hair down. Here, beyond the glare, is young Elizabeth's life as she liked it best. *Opposite:* During a visit to Canada, a member state of the Commonwealth realm, she enjoys a square dance. *Left:* She goes riding on the grounds of Windsor Castle with her sister, Margaret. *Above, left:* She and Philip stroll at Broadlands, an estate owned by Earl Mountbatten, the duke's uncle, during their honeymoon in 1947. A year later the couple will welcome their first child, Charles, and in 1950 their second, Anne; in the photograph above, big brother busses his baby sister. A decade will pass before Prince Andrew is born, and Prince Edward's subsequent arrival will complete the family.

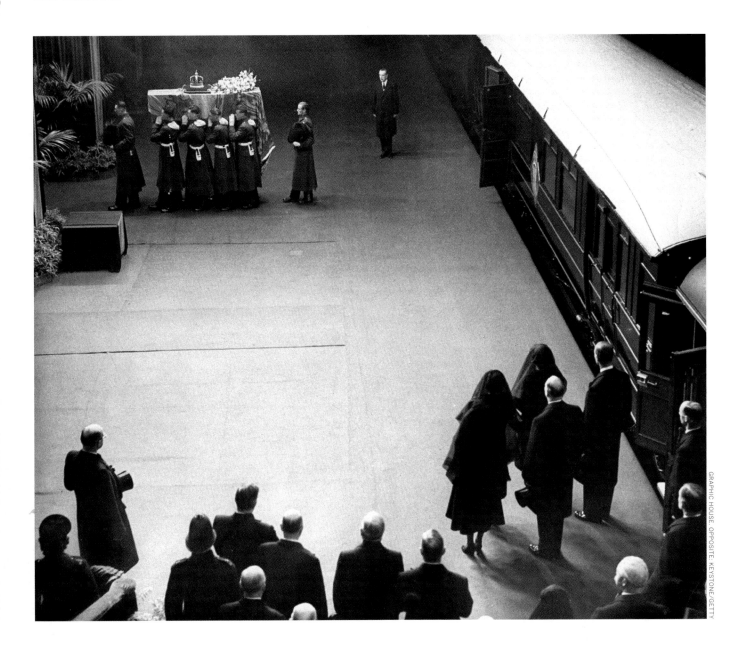

Unbeknownst to the nation, George VI was suffering from lung cancer in the early 1950s. However, it was a coronary thrombosis that claimed him while he slept at his estate at Sandringham on February 6, 1952. The 25-year-old Princess Elizabeth, who was at the royal hunting lodge in Kenya, immediately became Queen Elizabeth II; she hastened to London to grieve with family and help oversee funeral arrangements. All of England and its associated realms were stunned. The outpouring of emotion was great and immediate, which Prime Minister Churchill deemed proper: "We cannot at this moment do more than record the spontaneous expression of grief." Theaters across the land closed; the BBC canceled all but news programming; flags went to half-staff; the U.S. Congress voted to adjourn in honor of the king; hundreds of Londoners, not knowing what to do, gathered outside Buckingham Palace in a cold rain to share their sympathies—and tears. President Harry S Truman eloquently assessed this outsize reaction: "He shared to the end of his reign all the hardships and austerities which evil days imposed on the brave British people. In return, he received from the people of the whole Commonwealth a love and devotion which went beyond the usual relationship of a king and his subjects." In the photograph above, the casket of George VI, bearing his wife's wreath and the Imperial Crown, is taken from the train after arriving in London from Sandringham. The king will lie in state in Westminster Hall between February 11 and the funeral, on the 15th. Opposite: George is mourned by his daughter, mother and widow. For slightly more than a year, an unusual situation presents itself as England enjoys three queens: the reigning Elizabeth II; the Dowager Queen Mary (center), widow of King George V and mother of former kings Edward VIII and George VI, who herself was Queen Mother for nearly 26 years and who will pass away in 1953 just before her granddaughter's coronation; and the new Queen Mother, Elizabeth (right), who was only recently George's Queen Consort.

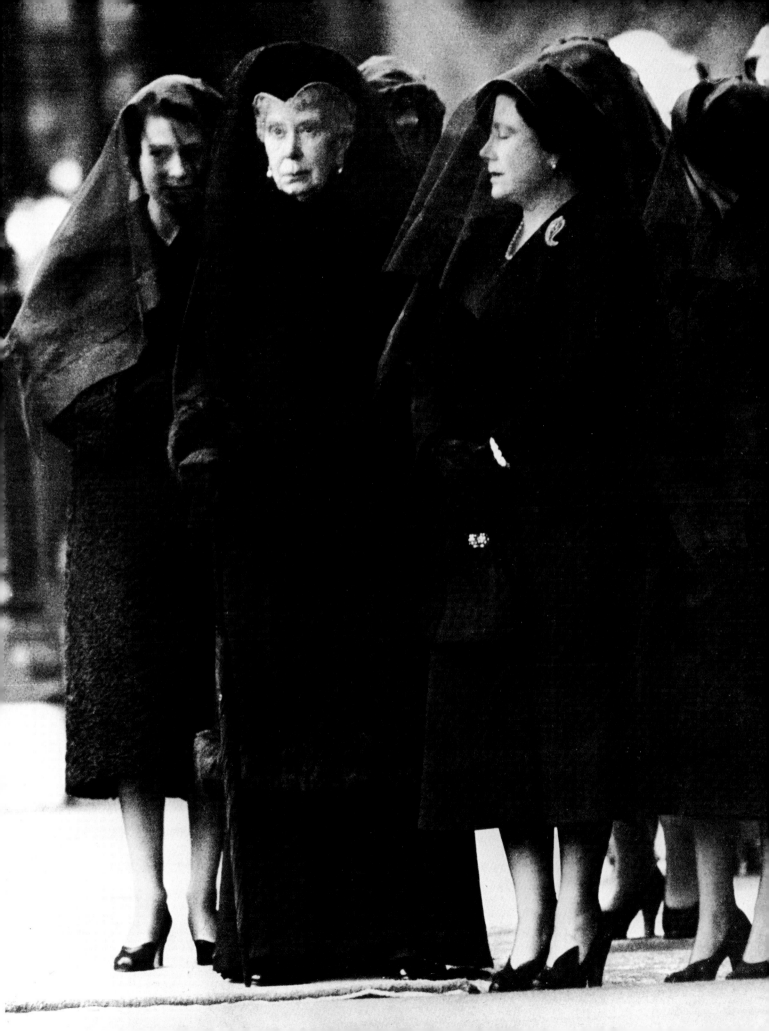

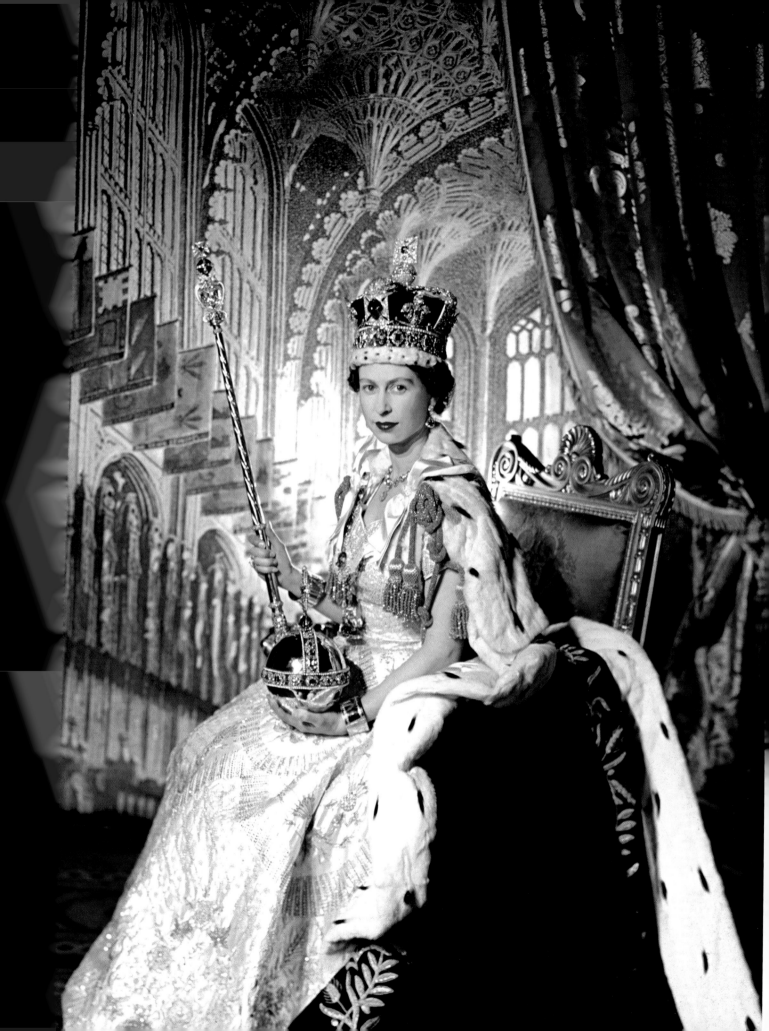

A Queen for the New World Order

We have already met the two daughters of George VI and Elizabeth, the older of whom was also named Elizabeth. At the time of her father's untimely death in 1952, after George's 16 immensely popular years on the throne, Elizabeth, born on April 21, 1926, was first in the line of succession. This would prove to be a good thing. None other than Winston Churchill had proved prescient when assessing the two-year-old Elizabeth after he had met her back in the '20s. "A character," he pronounced her. "She has an air of authority and reflectiveness astonishing in an infant." Her precocious intelligence and talents, as exhibited before Churchill and through her eloquence during World War II—an eloquence nearly matching her parents'—would serve her well as the House of Windsor pressed forth on its exceedingly odd and sometimes tortured course through the 20th century—and beyond.

Early in his reign, her father had ruled (so to speak; the British Empire had long since become a constitutional monarchy) over a community of countries that constituted a world power, perhaps *the* world power. Many of these realms truly were controlled by London (Westminster, if not Buckingham Palace). But when the dust settled after World War II, the United States and the Soviet Union were clearly the new superpowers, and meantime several of Britain's subject nations were maneuvering for independence. George VI was, for instance, the last Emperor of India. It might look impressive on paper that during Elizabeth's nearly six-decade reign, third longest of any British monarch after Victoria's and George III's, she became queen of 25 new countries within the Commonwealth. But this was because the "United Kingdom" was fractionalizing as more and more countries—Jamaica, Kenya, Fiji—gained real-world autonomy while remaining "loyal" to the Crown. Others—South Africa, Pakistan, Ceylon (which added to the indignity by changing its name to Sri Lanka)—chose, as had India, not to stay formally loyal, even if they remained friendly. The short of it: The monarchy that her parents had saved from a fate akin to death became ever more transparently a charade. A costume drama.

But the royals could always do dress-up well, even spectacularly. This was never more evident than with Elizabeth's coronation on June 2, 1953. Throngs filled all avenues and alleyways in orbit of Westminster Abbey, and, as the world had entered the modern age, the whole affair, minus the anointing itself and the communion, was televised globally. Twenty million Brits watched and millions more throughout the Commonwealth. Elizabeth endeavored to please, even to unite, them all. Her gown bore an emblem from each Commonwealth realm—from a New Zealand fern to an Irish shamrock—and then she and Prince Philip embarked on a half-year tour of the planet. The mania was intense, if a bit hard to fathom. It has been estimated that when she became the first reigning British monarch to visit Australia, she was seen by three-fourths of the population.

Good on ya, Your Majesty.

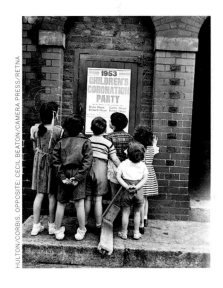

HULTON/CORBIS. OPPOSITE: CECIL BEATON/CAMERA PRESS/RETNA

Opposite: Queen Elizabeth II in her formal coronation portrait, which was taken by the famous photographer Cecil Beaton. Above: Kids in the East End get the lowdown on just one of the many celebrations being planned for the big day, which is June 2, 1953. As noted earlier in our pages, Elizabeth became queen immediately upon her father's death in February 1952. The lengthy wait for a coronation was in order to make careful and elaborate preparations for a truly grandiose celebration, and in hopes that a day in late spring might deliver good weather. In the event, the weather in London was typically gray, though this did little to dampen the enthusiasm of the participants in Westminster Abbey or the three million subjects who filled the city's streets.

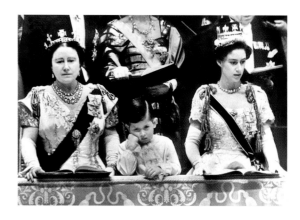

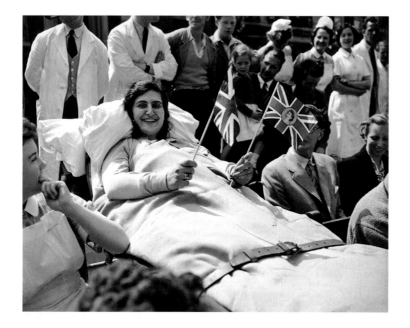

Left and above: Outside Westminster Abbey, Javail Shamloo, a patient at King's College Hospital, is all smiles as she ventures outdoors for the first time in two years in hopes of glimpsing the new queen, while inside the cathedral, Prince Charles is plum tuckered out as he weathers the long ceremony along with his grandmother and aunt. Below: Crowned, and with the royal orb and scepter in hand, Her Majesty the Queen is aglow as she heads off to board the Gold State Coach, which will bear her on a long and glorious military cortege through the city. The brilliant parade, featuring the different colors and styles of 29,200 uniforms—Rhodesian soldiers in short pants, Hindus in turbans—passes through Whitehall, Trafalgar Square, Pall Mall, St. James's Street and Piccadilly, into Hyde Park, under Marble Arch, down Oxford Street and into Regent Street (opposite), again through Trafalgar Square and finally under the Admiralty Arch and up the Mall to Buckingham Palace, where 8,000 guests will take part in the revels. Everywhere, all day long, the cry rings out: "God save the Queen!"

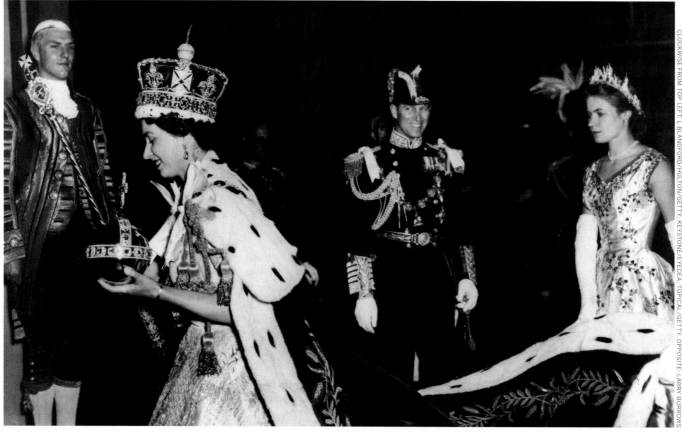

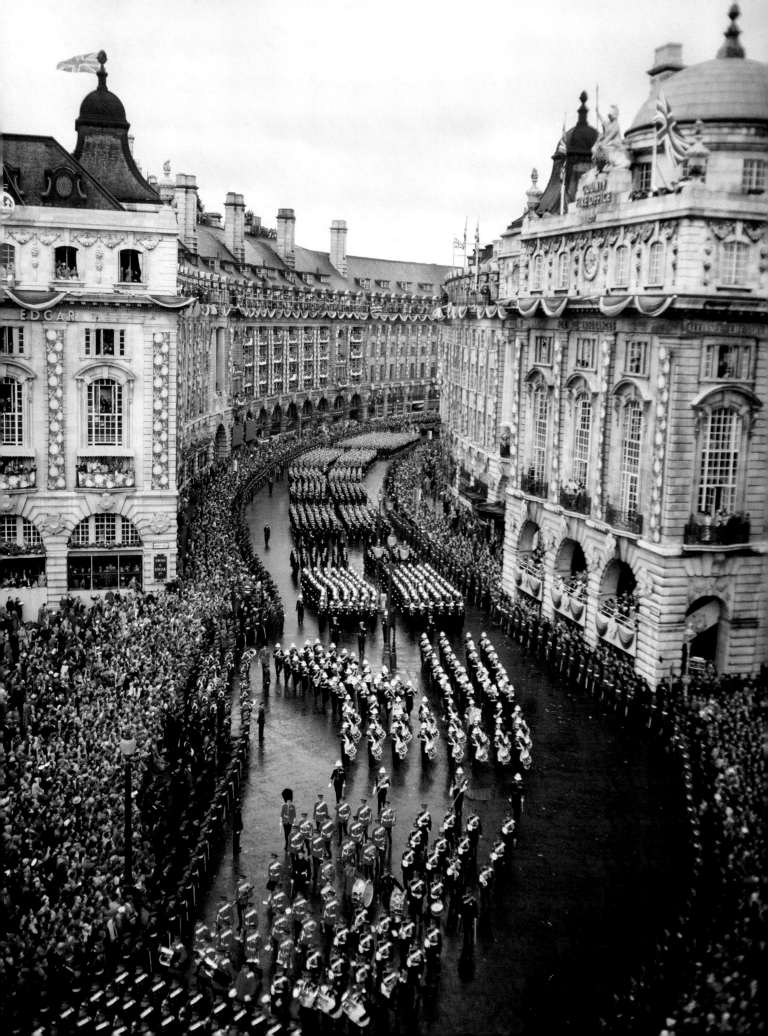

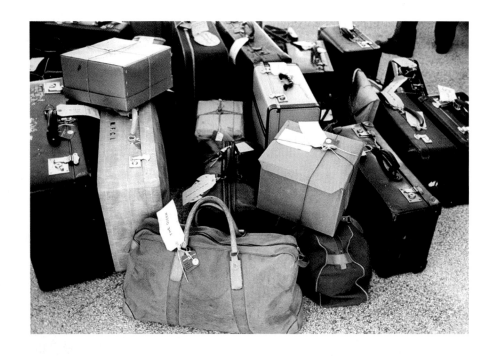

A whiz-bang press agent might have called it, "Elizabeth II's 'Sun Never Sets' Commonwealth Tour," for it did seem the new queen was out to prove that Britannia still bestrode the world like a colossus. In 1953 and into '54, she and Philip went everywhere, saw everyone, did almost everything. Left: The smallest sampling of the luggage employed by the queen and her entourage. Below and on the opposite page, bottom left: Two scenes in Jamaica, as the queen extends a gloved hand to an elderly dignitary, and a large group of girls wearing matching white dresses and hats assembles curbside to await the royal procession. Top: Elizabeth and Philip are in Tonga, where they are told that this ancient but still hale and hearty tortoise had been a gift from England's own Captain Cook. Bottom right: On Christmas Eve it's lovely weather during an early summer's day in New Zealand, as Elizabeth, on the steps of Government House, uses her movie camera to capture footage of Santa Claus bringing presents for her children.

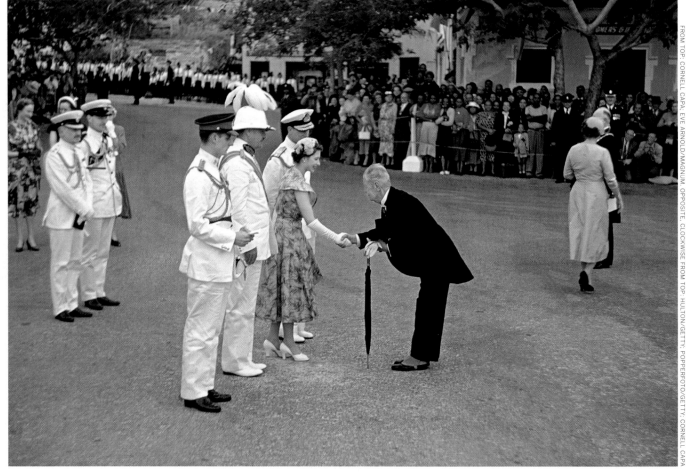

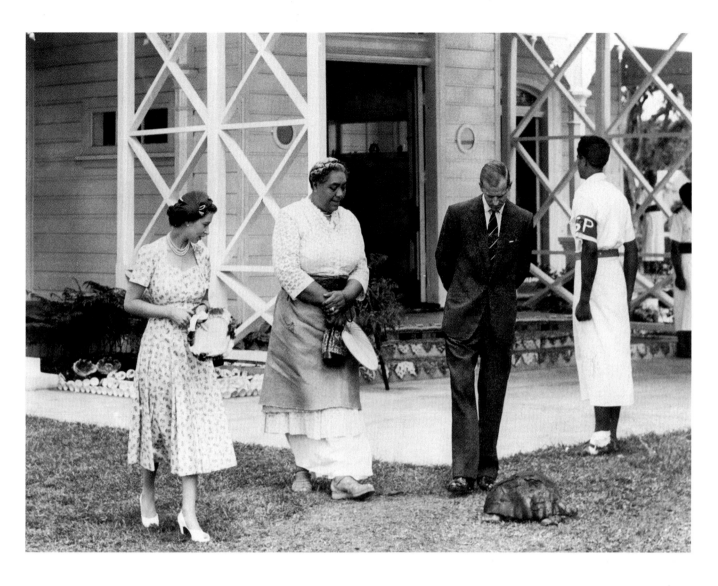

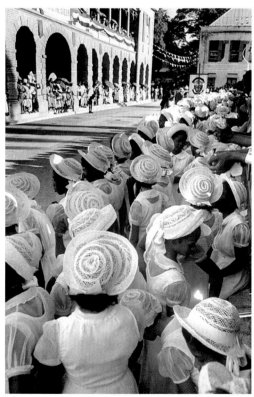

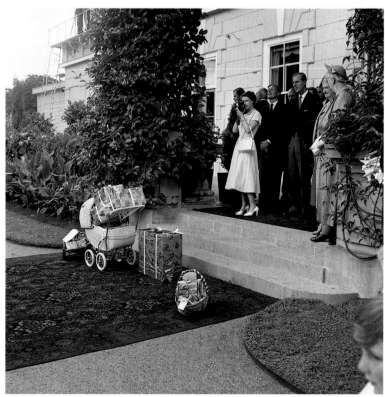

ROYALS ROUND THE WORLD

In ancient times, many nations other than England were ruled by kings or queens. Even in the present day, some still are. On these pages: a survey of royals beyond the Commonwealth.

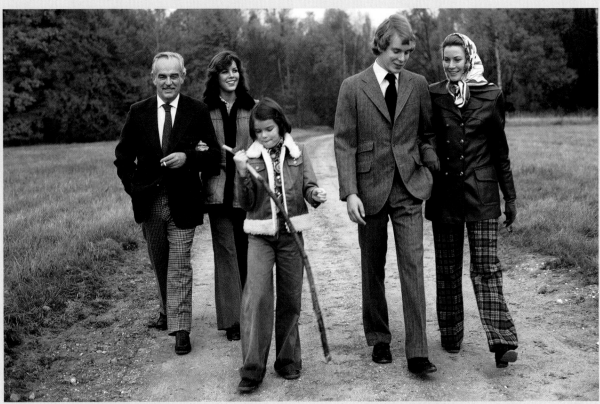

If the world ever saw a lovelier princess than Grace Kelly, she must have been named Cinderella. Above, the Princess of Monaco with husband Prince Rainier and children Caroline, Stephanie and Albert in 1973 in Marchais, France. Opposite, on her wedding day in 1956.

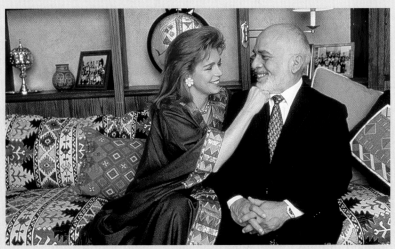

Queen Noor, who was known as Lisa Halaby when growing up in the United States, flirts with her husband, King Hussein of Jordan, in 1995.

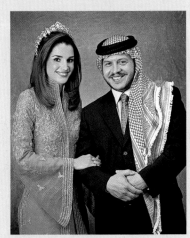

Hussein died in 1999. Here, in 2000, is Jordan's new king, Abdullah II, posing with his wife, Queen Rania.

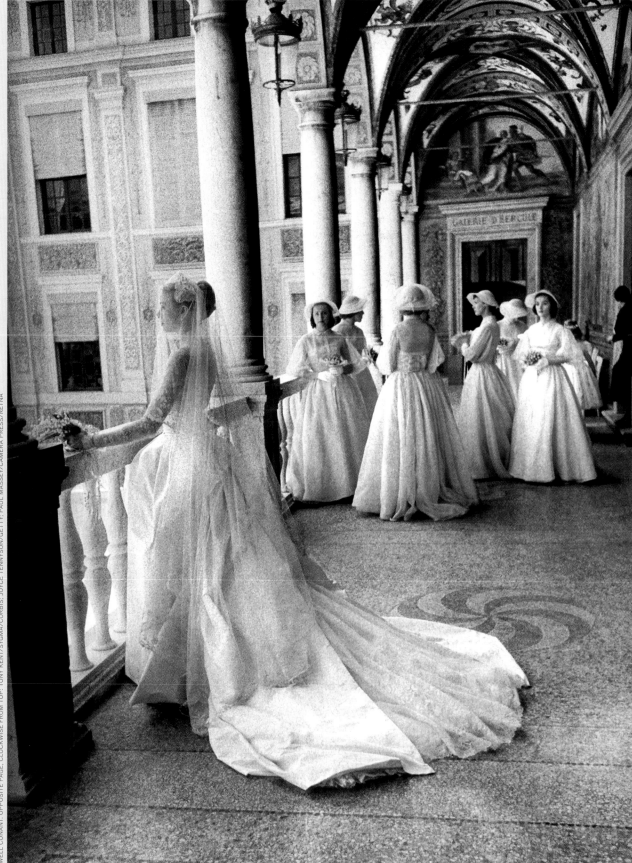

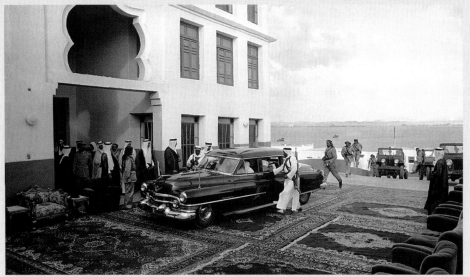

In 1953 Saudi Arabia's King Saud enjoys his very snazzy wheels, a Cadillac limo ready to roll on the carpet.

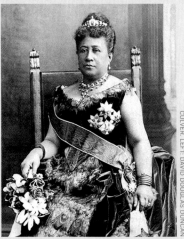

Hawaii's last-ever queen, Lili'uokalani, poses for a portrait in the late 19th century. She was deposed in 1893 and the Hawaiian kingdom ended.

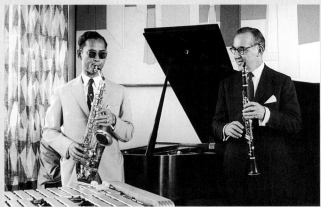

Two kings: Thailand's Bhumibol Adulyadej plays sax (left) with the King of Swing, clarinetist Benny Goodman, in 1960. Today, Bhumibol's reign is at 64 years and counting.

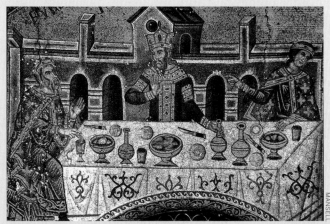

Herod Antipas inherited territories including Galilee from his father, Herod the Great; he also inherited a host of trouble when Jesus Christ came along.

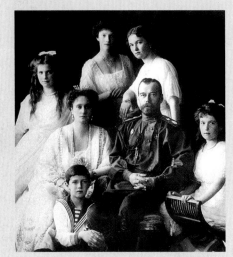

The Romanovs—daughters (clockwise from left) Maria, Tatiana, Olga and Anastasia; son, Alexis; Tsarina Alexandra and Tsar Nicholas II—were executed in Russia by the Bolsheviks in 1918.

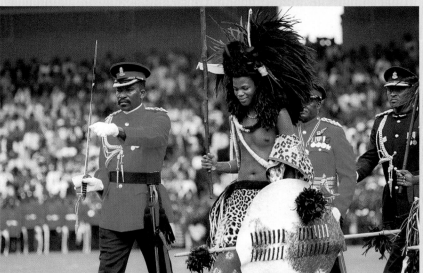

Swaziland's new king, 18-year-old Mswati III, smiles to the crowd at Somhlolo National Stadium after his April 25, 1986, coronation. His reign is currently at 24 years.

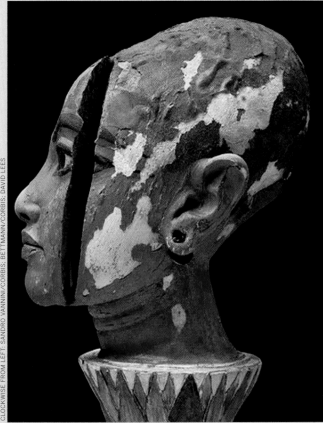

Japanese Emperor Hirohito reviews the troops in 1931. He supported Japan's militarization movement and led his nation into World War II.

Found at the entrance to the tomb of Tutankhamun in Egypt was this bust of the king seen as the god Nefertem, who was symbolic of rebirth.

Martial artists Prince Juan Carlos of Spain, right, and King Constantine II of Greece mix it up in 1966 on the Greek island of Corfu.

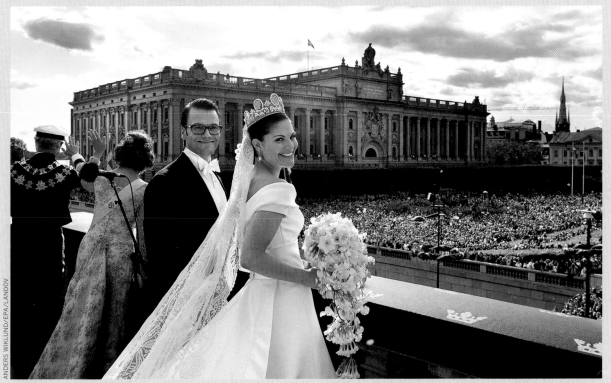

On June 19, 2010, all of Stockholm exults as Crown Princess Victoria of Sweden and Prince Daniel Westling appear on the balcony of the Royal Palace after their wedding. The princess's parents, King Carl XVI Gustaf and Queen Silvia, are at left.

The
ROYALS
in
OUR TIME

The Windsors have survived into the
new millennium despite their occasional
efforts to force the British citizenry to
give up on them altogether. They have
seen one of their own abdicate his throne
and have survived scads of subsequent
scandals and incidents of public silli-
ness. But whenever the situation seems
dire for the royals, one or another—the
Queen Mum, Elizabeth II, Lady Di
(opposite), her son William—steps up,
captures the public's fancy and bears the
Windsor standard onward.

FAMILY AFFAIRS

An Englishman wouldn't have been caught dead snickering about the shenanigans of Henrys I or VIII, or of any of the half-dozen Henrys between. Or maybe he would have been. Caught dead, that is.

But with the Windsors, snickering about the royals has become not only a national pastime in England but a global sport. Not every single country loves soccer, but all of them get a kick out of making fun of the present-day British monarchy.

This is not Elizabeth's fault. She has been a fine and routinely faultless queen, her tone-deaf response to Diana's death notwithstanding. But her relatives have been quite another matter. The royals in our time have been featured on the gossip pages far more often than on the front pages.

If Edward VIII set a standard tough to trump when he abdicated, he did so by only a hair. Consider Elizabeth's kid sister, Princess Margaret, born in 1930, the little girl who looked so sweet in those family photographs on our earlier pages. Even as Elizabeth was preparing for her coronation, Margaret told her that she wanted to marry a divorced commoner 16 years her senior—a societal sin nearly equal to Edward's. Elizabeth asked her to wait a year before announcing any engagement, and eventually Margaret gave up Peter Townsend and fell into the arms of photographer Antony Armstrong-Jones, who would be created first Earl of Snowdon by Queen Elizabeth after this first televised royal wedding from Westminster Abbey. The Snowdons were the palace's ambassadors to the Swinging Sixties scene in London, counting as friends the Beatles and the Rolling Stones. The princess was credited by Fleet Street with numerous affairs—the names of Mick Jagger, Peter Sellers and David Niven were floated—and she and Lord Snowdon divorced in 1978. Margaret liked scotch and really liked cigarettes, and died in 2002 at age 71.

Elizabeth's husband, Philip, was, as we know, a foreigner—nothing indictable there. But he had two sisters who married German nobles cozy with the Nazis; these men fought against the Allies in the war. Not Philip's doing, certainly, but it's the kind of thing—like the prince's several later gaffes when speaking in public—that energized the chattering classes.

As we all know, unless we have had our hands over our ears these past several decades, there was much more to be offered—by the queen's oldest son, Charles; by Charles's wife, Diana; by Diana's best pal who married into the House, Fergie.

Fergie! My goodness!!

That Elizabeth II somehow managed to maintain her dignity and popularity through it all is a minor miracle. If her father saved the monarchy in the 20th century, she carried it, sometimes single-handedly, into the 21st.

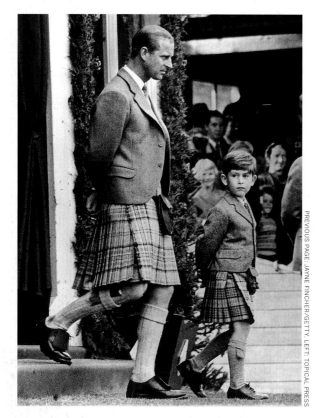

PREVIOUS PAGE: JAYNE FINCHER/GETTY. LEFT: TOPICAL PRESS

PIX INC. OPPOSITE: GLOBE

In the 21st century, the informed wisdom is that Elizabeth and Philip's relationship resides somewhere between aloof and nonexistent. When they were kids, and she was so in love, they were among the world's most romantic young couples—and young parents. Left: Philip, of Greek heritage, happily does the Scottish thing with son Charles. Above: Charles and his sister, Anne, happily romp in the same playhouse where their mother and aunt gamboled decades earlier (please see page 51). Opposite: Charles and Anne happily peruse a book while Elizabeth and Philip happily peruse the pastoral scene at a pond on the grounds of Buckingham Palace in 1957.

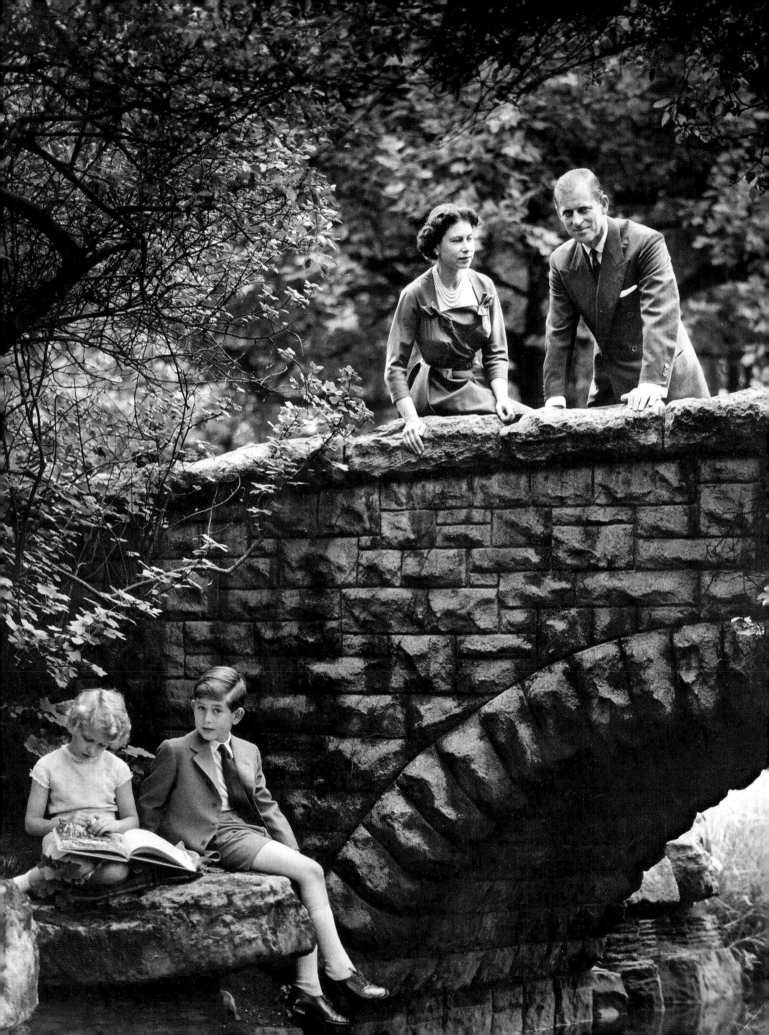

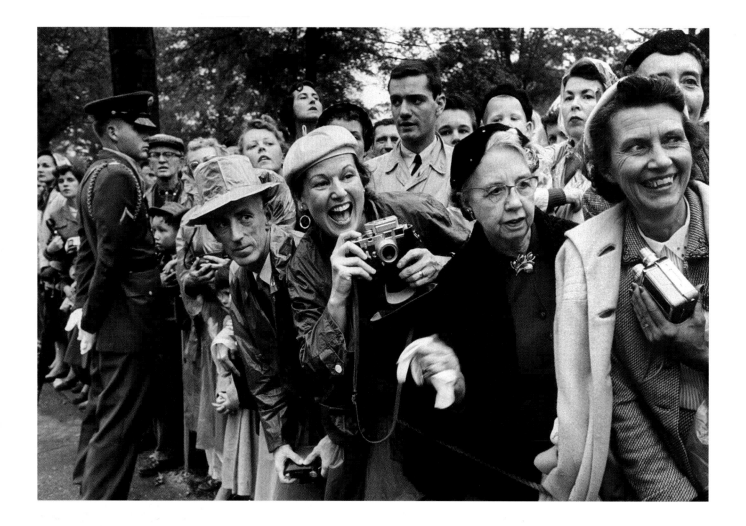

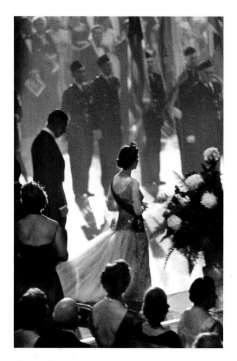

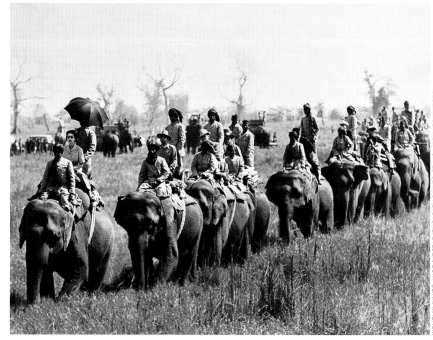

The world was their domain, the world's upper class their strata. Opposite, clockwise from top: In the former colonies, Yanks are agog as the queen and her consort arrive at Arlington National Cemetery in Virginia; elephants are the transport of choice in India in 1961 (India had gained its independence from the U.K. in 1947 but remained friendly with its former overlord); Elizabeth and Philip in New York on their 1957 visit to the States. Left: Charles, age nine, heads off to Cheam boarding school. His first headmaster in West London advised Elizabeth to get Charles involved in football (we call it soccer) since no deference was shown on the football field. Below: Philip, Jacqueline Kennedy, Elizabeth and U.S. President John Fitzgerald Kennedy at Buckingham Palace in 1963. Interestingly, one of Jackie's last and biggest assignments as a young photographer for a Washington, D.C., newspaper in 1953 had been to shoot the queen's coronation.

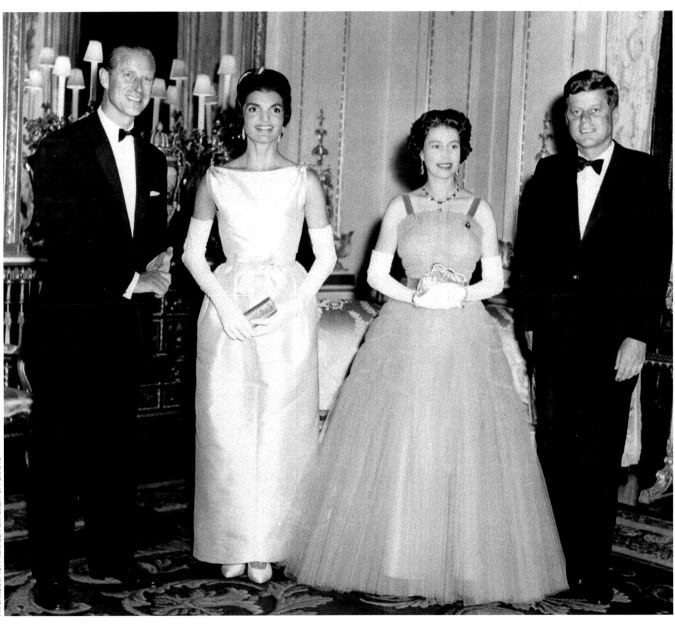

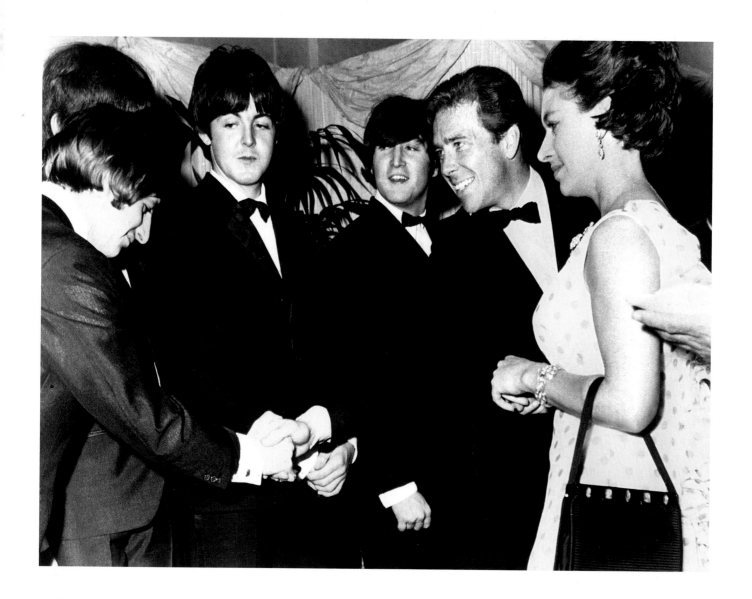

In the 1950s and '60s, the dividing line between royalty and tabloid celebrity was breached, and ever since then things have been different. At late-night after-parties in Kensington Palace, Margaret and Snowdon played host to the hottest of the hots. *Opposite, top:* They greet the Fab Four (George is hidden behind Ringo) at the world premiere of Help! *in 1965. The princess's association with the Beatles had begun, rather famously, in 1963 when she and her husband attended the Royal Variety Show at London's Prince of Wales Theatre, and John Lennon had, at one point, taunted the audience: "For our last number, I'd like to ask your help. Would the people in the cheaper seats clap your hands. And the rest of you—if you'd just rattle your jewelry." Bottom: On the set of* Torn Curtain *in Los Angeles, megastar Paul Newman exits stage left as Snowdon laughs, Margaret smiles and director Alfred Hitchcock, yet another Brit, exhales. Right: After the 1968 Royal Variety Show, Margaret meets Motown's Supremes. Below: Royals can do backyard barbecue too, as Philip and daughter Anne prove at the grill in 1970.*

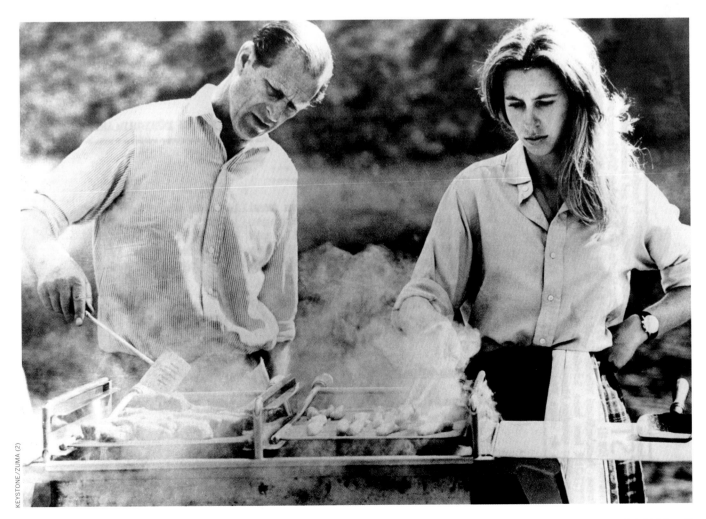

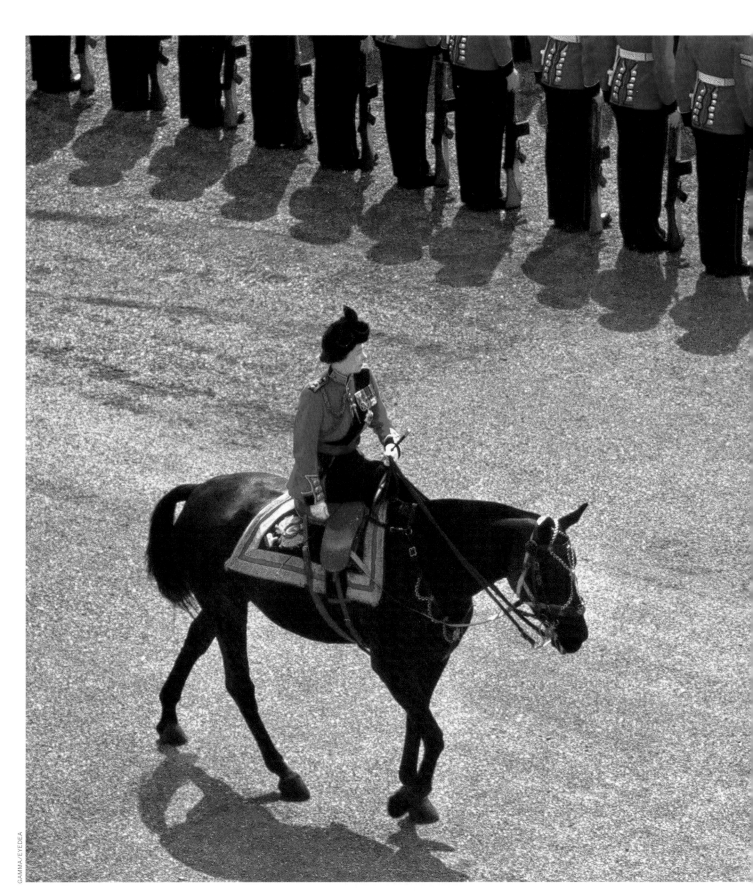

On one of the first three Saturdays of June each year, in honor of the queen's official birthday (although she was actually born in April), as many as 1,400 officers and subordinates take part in a Trooping the Colour ceremony. Music provided by some 400 musicians accompanies the pageantry, as Elizabeth reviews—these days by carriage, formerly on horseback—her loyal guards. This has gone on since the reign of King Charles II in the 17th century and is a splendid ceremony indeed. Of course, as any American who has watched the Wimbledon tennis tournament on television would know, it can get terribly hot and humid during a London June. And, as anyone anywhere might imagine, it can jolly well get uncomfortable in a full uniform and furry hat during such weather. At left we see, during the 1970 festivities, the queen, quite upright, and one of her men, not so much. He has fallen victim strictly to the climatic conditions, not to the concluding 41-gun salute, and will be successfully revived.

THE MAN WHO WOULD BE KING

Born in 1948, the eldest of Elizabeth II and Philip's four children (three of them sons, including Princes Andrew and Edward; their sister is Princess Anne), Charles, Prince of Wales, has been, since the death of his grandfather George VI in 1952 and his mother's subsequent accession, heir apparent to the many crowns of the Commonwealth—nearly six decades as first in line of succession. That has amounted to plenty of time to build a reputation. It is a measure of how the mores of society have changed that, were Elizabeth II to die tomorrow or for some reason step down, Charles would be crowned king, despite having divorced his first wife, Diana Spencer, in 1996 and married in 2005 (in the first-ever civil wedding on English soil of a member of the royal family) the divorcée Camilla Parker Bowles, a woman with whom he'd conducted an affair when both he and she were married to others.

Contrarily, however, a measure of how the British still insist on adhering to protocol and nodding to the past is that Charles and Camilla, in order to receive the Archbishop of Canterbury's blessing, were required to lead the congregation in attendance on the joyous matrimonial day in a recitation of an Act of Penitence from the Book of Common Prayer: "We acknowledge and bewail our manifold sins and wickedness, which we, from time to time, have most grievously committed by thought, word and deed, against thy Divine Majesty, provoking most justly thy wrath and indignation against us." Try convincing Bill Clinton to lead the twin houses of Congress in such a chorus. You couldn't with a gun to his head.

Well before Charles became famous for scandal, exacerbated greatly when unfortunate phone conversations with Camilla made their way into the papers, he was an upright and admired prince. He has always been a champion of charitable works and by all accounts a fine father to his two boys, the princes William and Harry. He has spoken out often and forcefully in favor of protecting historic architecture, authoring a book on the subject entitled *A Vision of Britain*. He plays polo and loves to hunt. He has also, for more than a quarter century, been an avowed environmentalist, and today fronts the organic brand Duchy Originals, which contributes about $10 million in profits each year to Charles's philanthropic causes. In 2007 he was given the 10th annual Global Environmental Citizen Award by the Harvard Medical School's Center for Health and the Global Environment, which in its citation lauded that "he has been a world leader in efforts to improve energy efficiency and in reducing the discharge of toxic substances on land, and into the air and oceans."

Charles's vision of Britain is clearly both old school, as befits a royal, and a little bit new.

Prince Charles's public behavior has been nothing if not theatrical, and this has always been so. A patron of the arts, he was long ago an enthusiastic participant in school musicals and revues. At right he rehearses one of the several sketches that he will appear in during the run of a Cambridge University production in 1969.

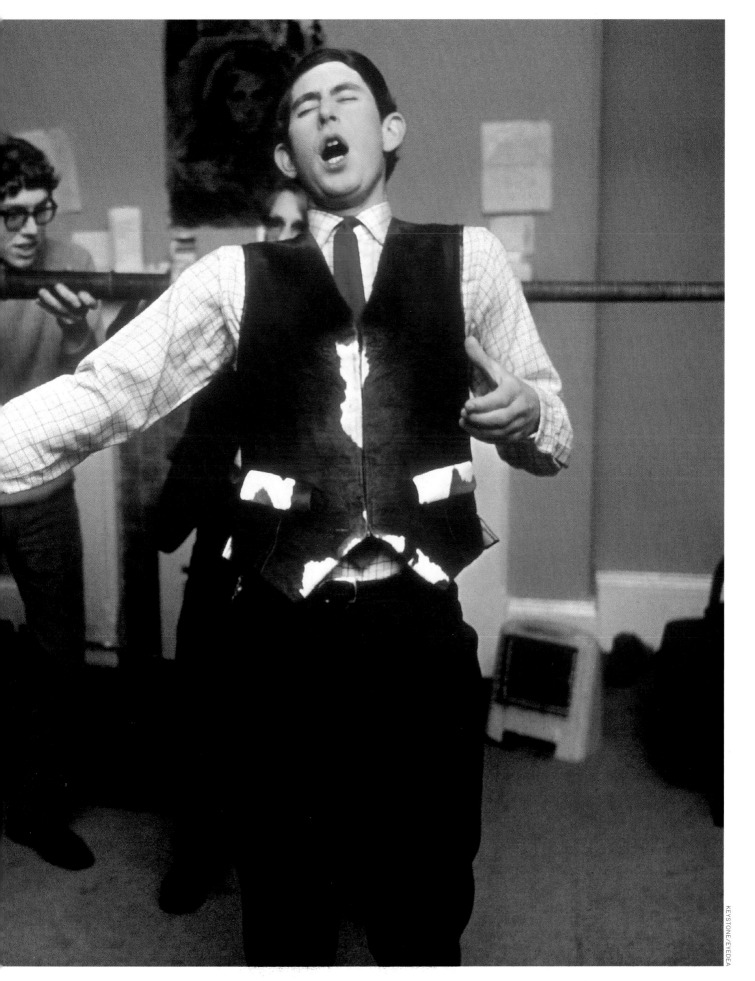

Being one of the planet's most eligible
bachelors keeps a prince busy. There
was Georgiana Russell, the daughter of
Britain's Spanish ambassador; Lady Jane
Wellesley, the daughter of the Duke of
Wellington; Davina Sheffield; model Fiona
Watson; Susan George; Princess Marie
Astrid of Luxembourg; Dale, Baroness
Tryon; Janet Jenkins; Jane Ward; and on
and on. On these pages, a sampler. Above
we see Charles in 1970 leaving the Fortune
Theatre in London with Lucia Santa
Cruz, daughter of the Chilean ambassador
to England, after attending a performance
of David Storey's The Contractor.
Top right: In 1975, he hobnobs with the
already married Camilla Parker Bowles,
who will reenter the royal picture years
later. Bottom right: In 1977, he schmoozes
with Sarah Spencer before competing
in the Smith's Lawn Cup polo final on
the grounds of Windsor Castle. One of
Sarah's kid sisters, Diana, is destined to
play a large role in this evolving social
drama, as we will see on the pages immedi-
ately following. Opposite: In 1979, Charles
is way down under in Perth, Australia—
but not beyond the camera's reach—when
bikini-clad model Jane Priest takes her
shot . . . and a paparazzo takes his.

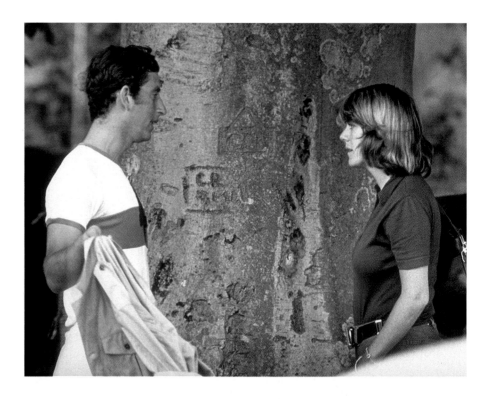

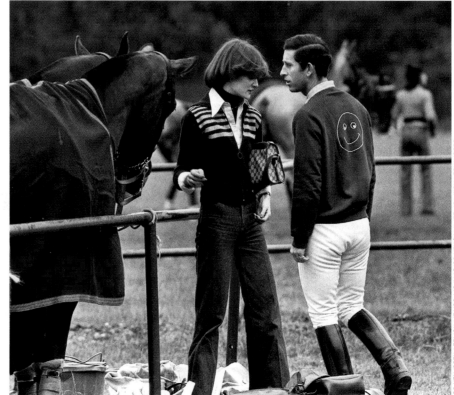

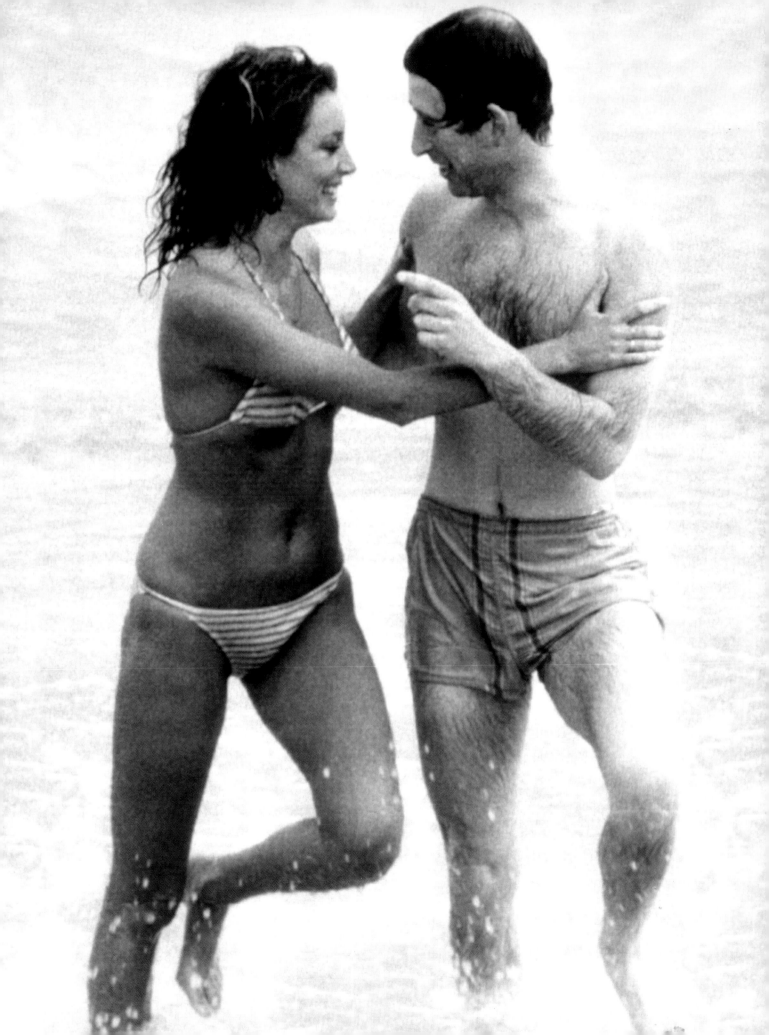

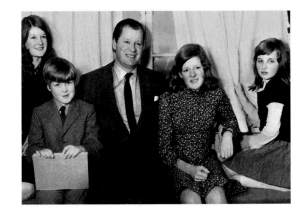

The chosen one: Charles decided that Diana Spencer should and would be his bride, and the world at large decided that she was indeed the fairest of them all—the prettiest and altogether most perfect princess since Grace Kelly. On the opposite page young Di salutes twice, circa 1970. As for the family portrait: Her father, Earl Johnnie Spencer, is already split from her mother at this point, and so we have only him and his kids, from left, Sarah (who will briefly date the Prince of Wales), Charles, Jane and Diana. Left: How awkward it might have been on October 24, 1980, when Diana (at right) and Camilla Parker Bowles chatted during the Amateur Riders Handicap Steeplechase at the Ludlow racecourse, a competition in which Prince Charles was competing, is anyone's guess. Below: At Buckingham Palace in 1981, the fairy-dusted couple smile during what were, perhaps, their happiest days together.

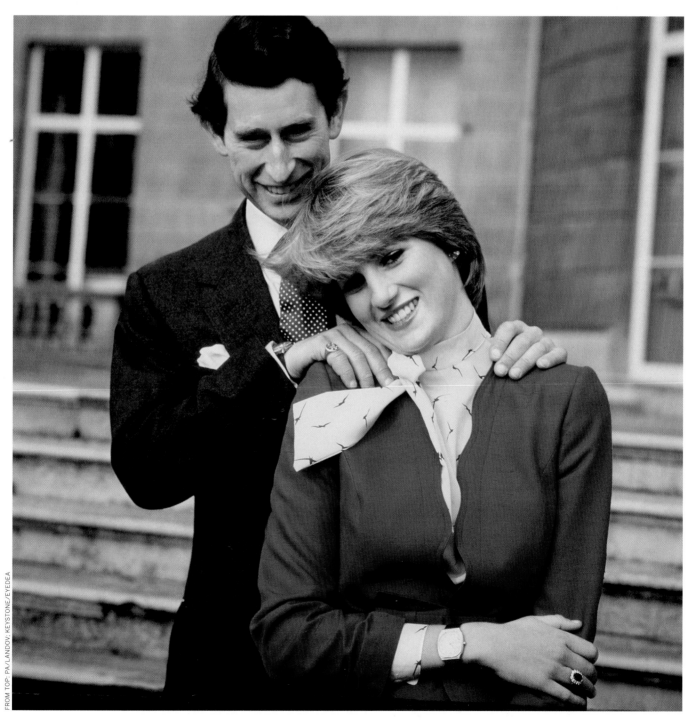

THE LOVELY AND LOVABLE LADY DI

We have briefly met, on the pages immediately previous, Diana Frances Spencer. Here, we can only briefly describe this woman about whom more words have been typed than perhaps any other in the 20th century. We leave it to you to decide whether she was a power-hungry manipulator of the media, as her friend the journalist and editor Tina Brown alleges; a sympathetic humanitarian with a deep love of children, as other biographers describe; or, most likely, something in between. Whatever the case, her life on the world stage was extraordinary, drawing outsize attention, eliciting scorn and sympathy at regular intervals.

She was born, in 1961, to nobility, her father being John Spencer, Viscount Althorp, later the eighth Earl Spencer (she was a direct descendant of King Charles II through four illegitimate sons). Before she was 10, her parents divorced unpleasantly after her mother, Lady Althorp, had an affair; these parents would battle protractedly for custody of Diana and her younger brother, and the siblings' adolescence was split between the mother's apartment in London's fashionable Knightsbridge section and their father's home in Norfolk.

The preparatory schools Diana attended can be readily imagined. Despite the expert teaching, however, she never became any kind of scholar. Her grace and social skills, by contrast, were A-plus. She worked, among other small jobs, as a hostess at parties before she began seeing Charles in the summer of 1980, at which point she was presented to the world at large. She seemed in all ways (including the legal ones determining succession to the throne) perfect—English, virginal—and Charles, then in his early thirties, was under public pressure to settle down. Though counseled by friends that he did not seem to be in love with Diana, he was pushed by his father, Prince Philip, to make up his mind. Charles proposed marriage in February 1981, and Diana picked out a ring consisting of a sapphire surrounded by 14 diamonds. That was just the beginning of splendor as the world was swept up in this storybook romance. Via television, 750 million people worldwide watched Diana walk down the aisle of St. Paul's Cathedral on July 29, 1981, wearing an exquisite dress with a 25-foot train.

On September 6, 1997, 2.5 billion globally would watch Lady Di's funeral, televised from Westminster Abbey.

Between those dates, as the latter TV rating implies, Her Royal Highness the Princess of Wales (after her divorce: Diana, Princess of Wales) became one of the world's most beloved figures. Her impeccable style, her tireless work on behalf of countless charities, her evident rapport with children and the poor and her bred-in-the-bones charisma drew the multitudes to her. She could misbehave, she could say silly things (sometimes on tape!), and none of it seemed to matter.

The Windsors had, somehow, selected a woman who would dwarf them all.

Lady Diana was only 20 years old when she survived one of the most extraordinary days a young woman has ever survived. She arrived at 11:20 British Standard Time, having made the journey from Clarence House to St. Paul's Cathedral in the Glass Coach with her father, Earl Spencer. She never stumbled during the three and a half minute walk up the red-carpeted aisle in her gorgeous ivory taffeta and antique lace gown designed by David Emanuel. If her nerves showed this day, it was during the vows themselves, which were administered by the Archbishop of Canterbury, Dr. Robert Runcie, assisted by clergymen from several denominations (pages 86–87). In a slipup that was not held against her, she called her betrothed Philip Charles Arthur George rather than Charles Philip Arthur George. Not an omen or a harbinger, surely, just an oops.

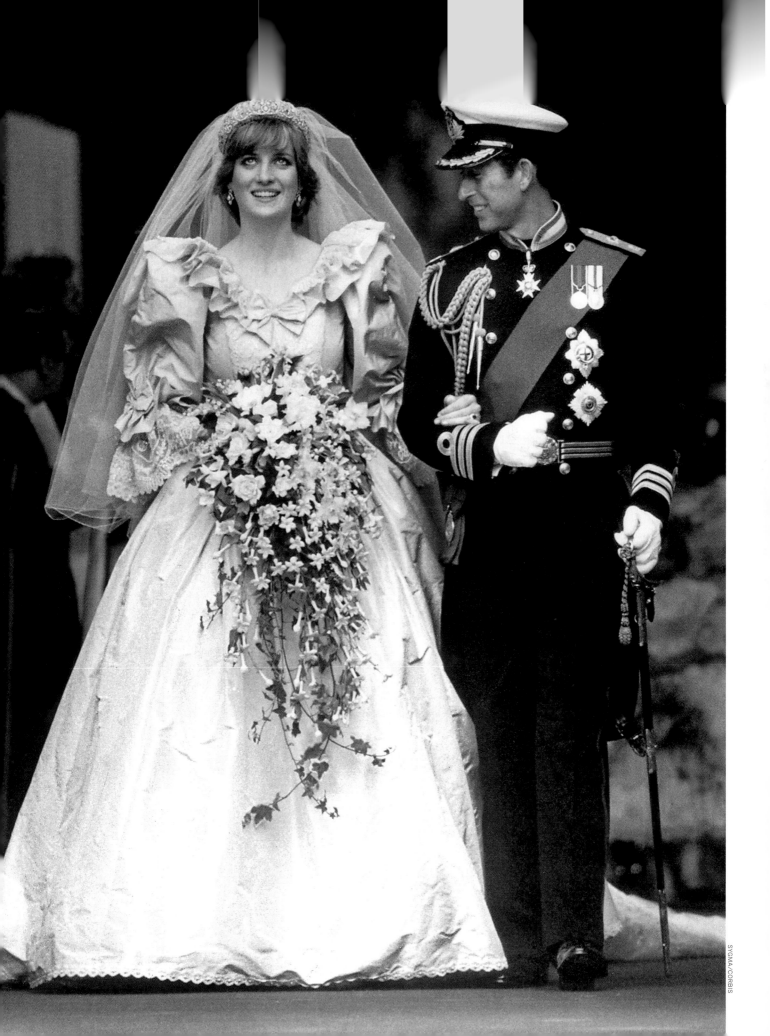

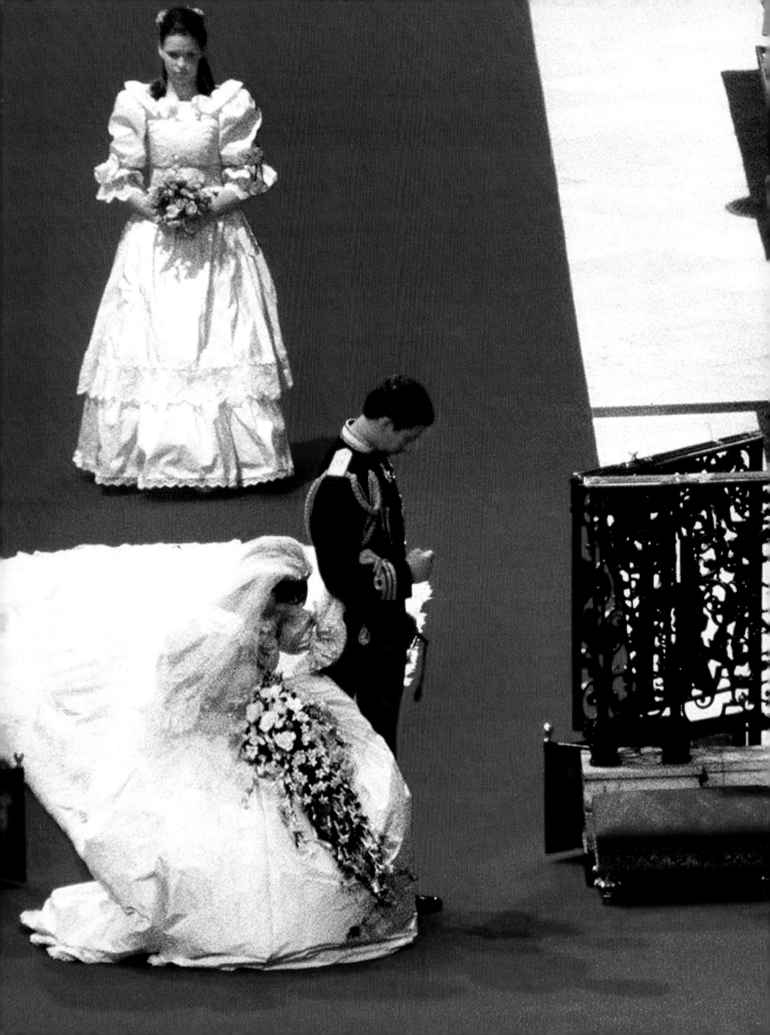

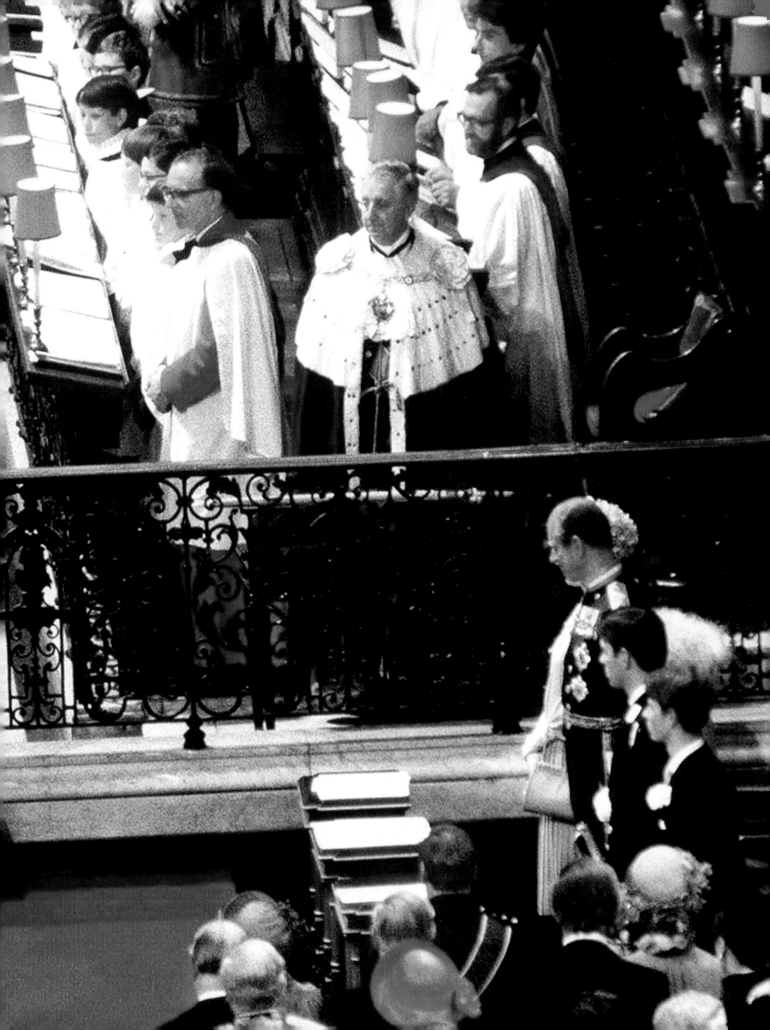

Right: St. Paul's Cathedral is, along with Westminster Abbey, the Tower of London and Buckingham Palace, one of London's truly great buildings. This august Anglican house of worship atop Ludgate Hill, the highest point in the City of London, was designed in the 17th century by the fabled architect Sir Christopher Wren; it became the fifth St. Paul's to rise on that spot since A.D. 604. From 1710 to 1962, the 365-foot-high edifice was London's very tallest. Nicked during the Blitz in World War II, it survived proudly. Years later it was made famous to movie audiences during the "Feed the Birds" song in Mary Poppins. *The funeral services for Lord Nelson and Sir Winston Churchill were held here, as were the jubilee celebrations for Queen Victoria and the peace services to mark the ends of two 20th century world wars. Although Westminster is the site of most royal weddings and funerals, St. Paul's was chosen for the nuptials of Charles and Diana, which were attended by 3,500 invitees. As the couple descend the steps, at right, Di's tremendous train in tow, the huzzahs ring out.*

Pages 90–91: Among the many, many fun things about royal weddings is that stretch limos are out, and horses and coaches and carriages (here, the open-topped state landau) are very much in. So are medals and embroidery and all manner of highfalutin haberdashery. In this picture we see Di giving the regal wave an early tryout, Charles in the full dress uniform of a naval commander, and a small sampling of the 600,000 subjects who have filled London's streets to cheer the newlyweds. We also see attendants who might have stepped right out of Henry VIII's court or Napoleon's army: Time does not stand still at royal weddings, it races backward. Apparently, the world needs such moments. Elgar's Pomp and Circumstance *filled the air as the Prince and Princess of Wales strode forth from the cathedral, and pomp and circumstance continued to be the theme of the day.*

Pages 92–93: A private moment, a precious picture. Thomas Patrick John Anson, the fifth Earl of Lichfield, would have been on the guest list anyway this day. But Patrick Lichfield, as the celebrity fashion photographer was more commonly known before his death in 2005, was also commissioned to be the official documentarian. There were, of course, countless posed tableaux, with Lichfield stage-managing the scene, telling kings and queens to do this and that, and when to say "Cheese!" In the aftermath, however, it became clear that the best picture of the entire day had been made when five-year-old Clementine Hambro—the great-granddaughter of Winston Churchill—bumped her head before being trotted out at the Buckingham Palace reception, and the solicitous Diana, newly a princess, leaned over to console her. Lichfield grabbed a simple little camera from his pocket, and voilà!

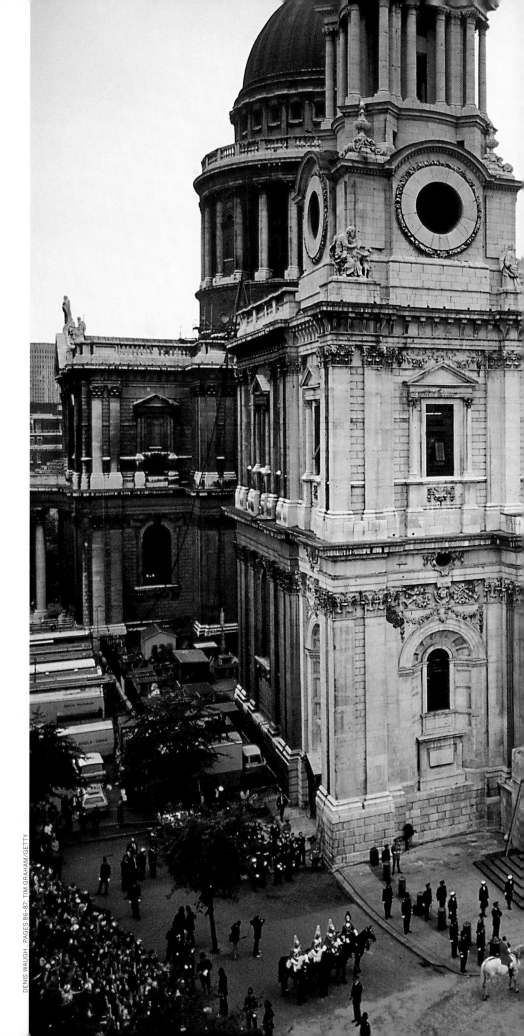

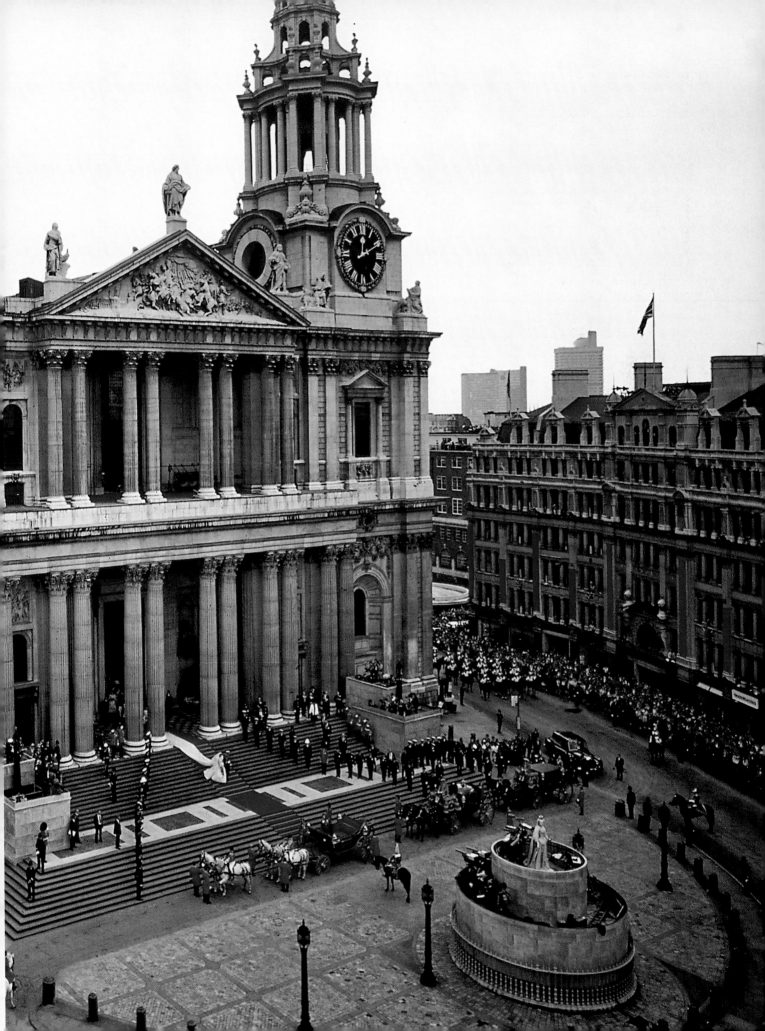

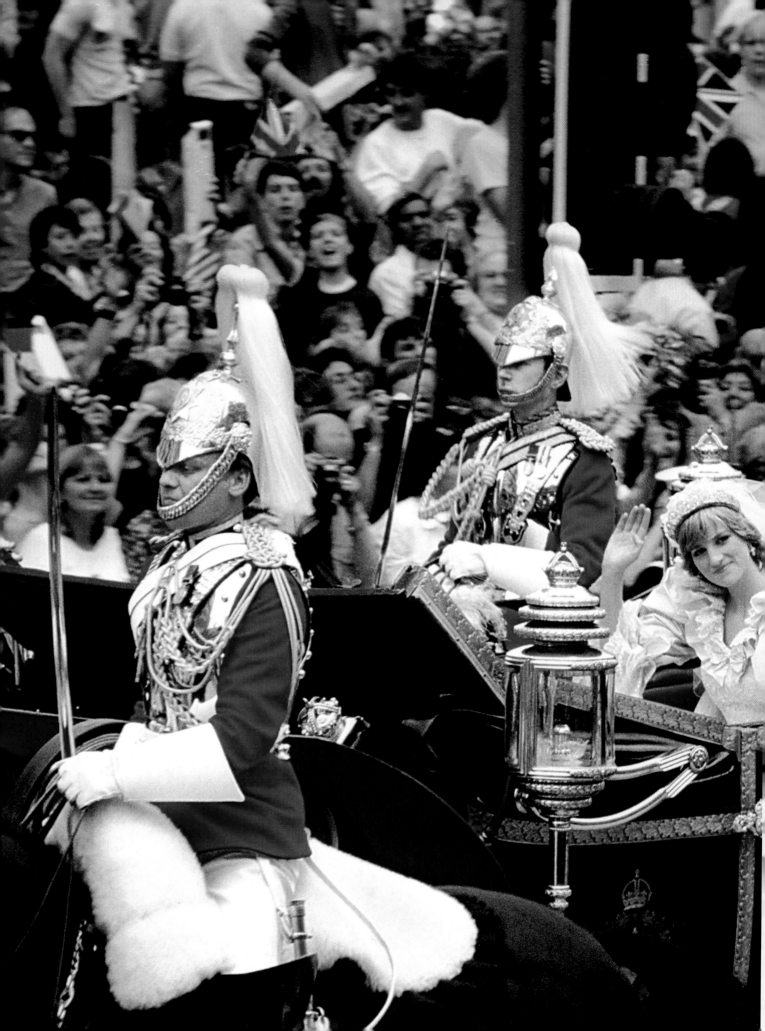

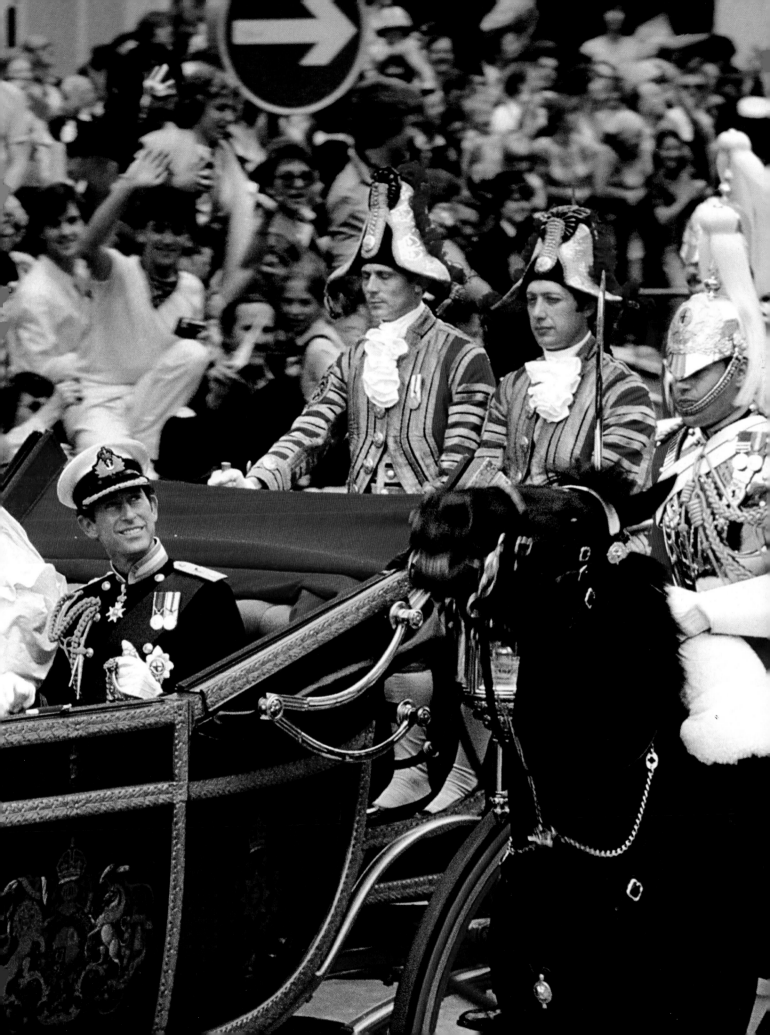

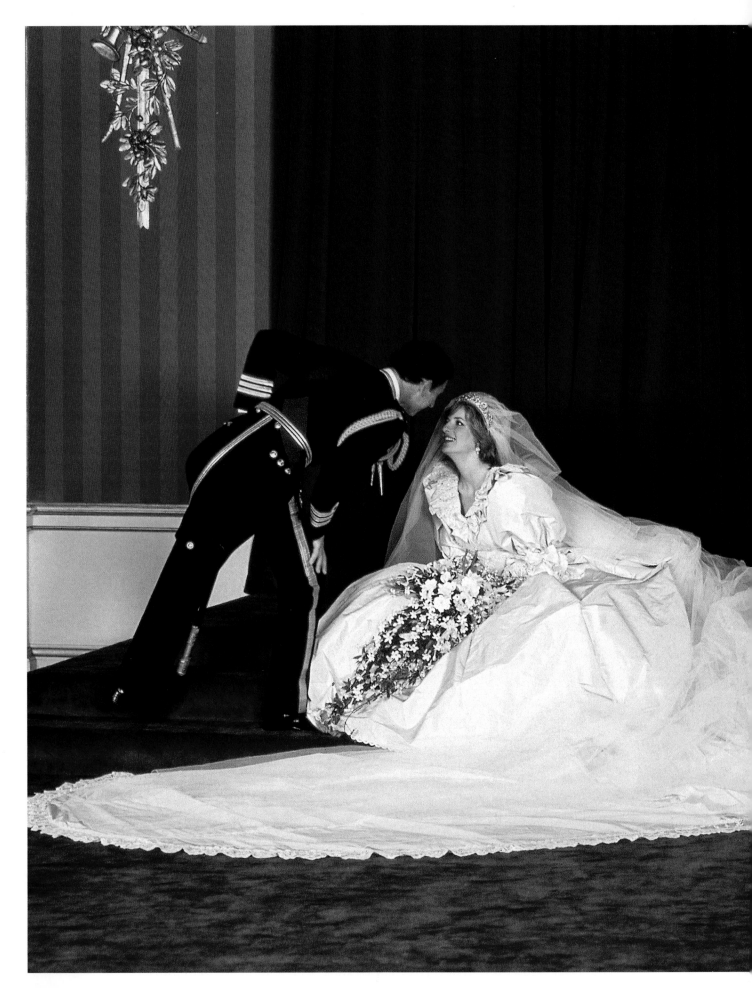

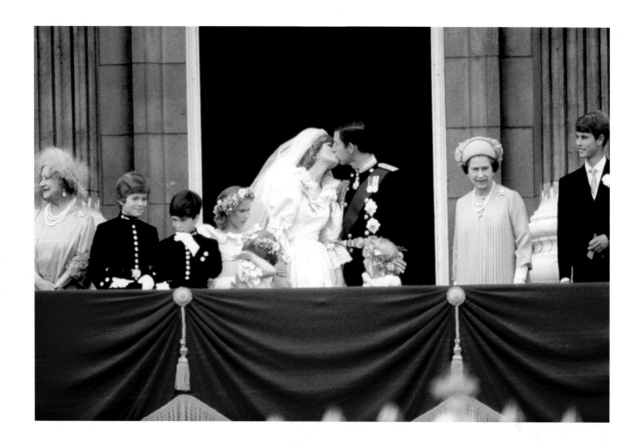

Information disclosed subsequently in our pages indicates that some folks—perhaps the bride and groom themselves—felt that the union was doomed from the start. But on the day in question, this looked like true love. Perhaps it was the hunger of the global audience for a royal romance that fomented this conclusion, but all—the prince, his princess, the rest of us—were complicit in concocting a fairy-tale narrative that out-Disneyed Disney. Left: At the palace, Charles pays gallant court to his bride. Above: At 1:10 British Standard Time, on Buckingham Palace's balcony, the newly-weds give the cheering public what they've been waiting for, the kiss of the century confirming the wedding of the century. Right: Fingers entwined, Charles and Di happily display the symbols of their love, his signet and her splendid but tasteful (not at all ostentatious) ring. Whether the honeymoon lasted a day or a year is debated today. That the marriage was in tatters within a half decade's time—even before the birth of their second child, Harry—is certain.

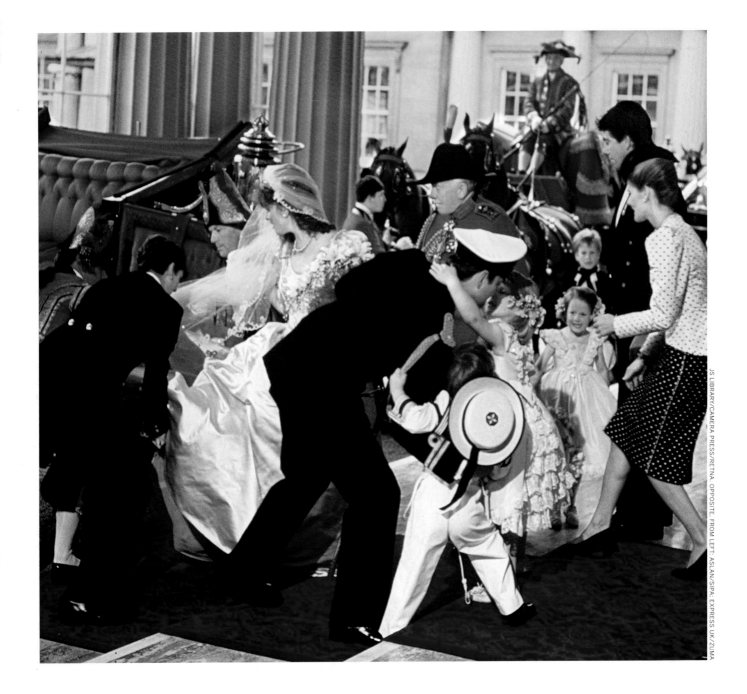

HOW DO YOU SOLVE A PROBLEM LIKE FERGIE?

Oh, Fergie!

Fergie, Fergie, *Fergie!*

It is hard to remember now, but when she first appeared on the scene in the mid-1980s, she was seen as a charmer—a bright, cheerful, effervescent redhead who brought pizzazz, a bit of life, to the royal orbit. It was a part she played well but that, she confided later, was ill-suited to her. In her 1996 memoir, *My Story*, she wrote, "I was never cut out for the job, and the harder I pushed, the more things fell apart. Even at my dizzy height of popularity, I knew the clock would strike 12 and I'd be seen for what I was: unworthy, unattractive, unaccomplished. And finally, logically, undone."

There is a woe-is-me aspect to that excerpt that seems to absolve Sarah Ferguson of a willful role in the dark comedy that has been her narrative since we've known her. The fact is, she enjoyed the high life, which she still covets, early on, jetting off for ski vacations in Switzerland and zipping around with Formula One driver Paddy McNally even as she was living in a $45-per-week flat in London's Clapham section and otherwise trying to make ends meet in knockabout employments at a PR firm and an art gallery. She had aristocracy in her blood, with both Stuart and Tudor antecedents, but she didn't have a big bank account—a fact that would forever be a factor.

One day, her pal Diana asked her if she would like to be Prince Andrew's date at the Royal Ascot races. Well, sure, why not? Who wouldn't? One thing led to another, and in early 1986 the couple were engaged; they married in London at Westminster Abbey on July 23 of that year, and Sarah became Duchess of York and a certified princess.

Opposite: A bit of happy chaos during the 1986 wedding of Sarah Ferguson and Prince Andrew at Westminster Abbey. Above we see the Duchess of York leaving Portland Hospital in London with her new baby, Princess Eugenie Victoria Helena, in 1990. At right, the girls, Eugenie (left) and Beatrice, with Dad, who has long since divorced Mom (planting a smooch), celebrate his birthday during a ski vacation in Switzerland in 2007. By this point, Andrew is the U.K.'s Special Representative for International Trade and Investment—a man of power. That Sarah might seek to exploit his influence could not have been predicted. But then, what sage could ever foretell Fergie's next unfathomable move?

Their marriage closely paralleled that of Charles and Di: They had two children (daughters in this case, the princesses Beatrice and Eugenie), but the bloom was off the rose within six years' time. It was noticed that when Andrew was off serving in the Royal Navy, as was his job, Fergie was sometimes in the company of other men, including Texas multimillionaire Steve Wyatt. The royal couple's separation was announced in January 1992, and a logical conclusion might have been: Well, that's the last we'll hear of Fergie.

Ha!

Before the year was out, paparazzi photos of the duchess, who was still married to the prince, were printed in the *Daily Mirror.* She was topless beyond a doubt and appeared to be having her toes nibbled by financier John Bryan, also of Texas. In her autobiography, Ferguson observed drolly of her evolving persona: "It would be accurate to report that the porridge was getting cold." She went on: "I was a royal duchess, and I had shown affection for a man not my husband, and had been found out—end of story."

Would that it had been!

When Diana settled financially with Charles, she received a proper princess's settlement—a lump-sum payment of approximately $30 million. Fergie, by contrast, was granted about $20,000 per year, based upon Andrew's naval salary, though she was allowed to stay on in rooms adjacent to Windsor Castle.

She went to work. She parlayed her eating problems into a gig as a spokesperson for Weight Watchers (not exactly what Buckingham Palace had in mind) and wrote children's books. She dreamt out loud about becoming England's Oprah. She continued to fly first class, and eventually the well ran dry.

In May 2010, *The News of the World,* in a sting operation, induced Fergie to promise to give a "businessman" (actually, a reporter) access to her ex-husband, Andrew, in return for a sum just north of $750,000. "I very deeply regret the situation and the embarrassment caused," she said this time. She explained further: "I have not got a bean to my name . . . I left the royal family for freedom, and in freedom I am bereft, I'm hopeless."

End of story? Don't bet on it.

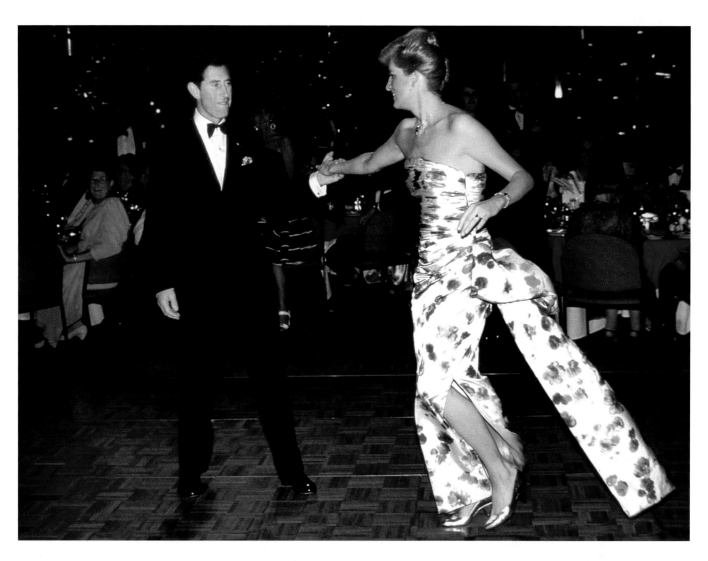

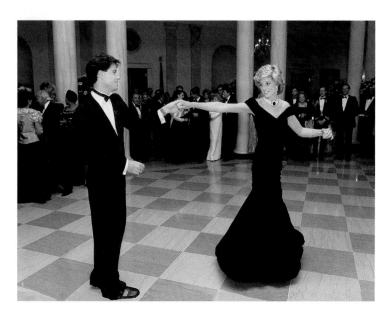

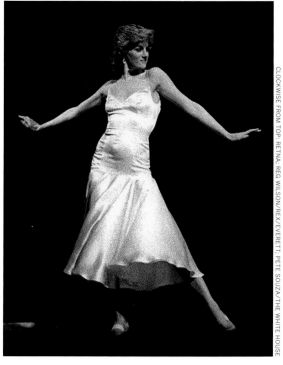

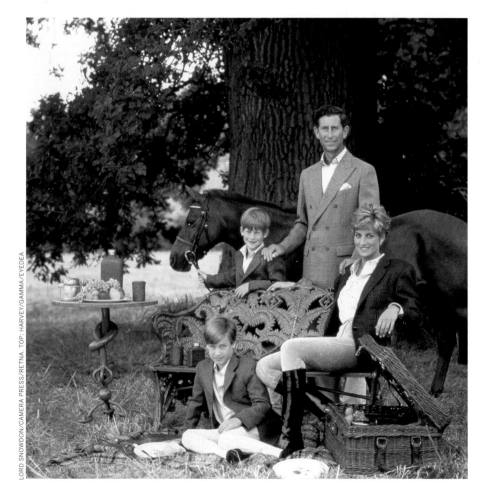

LORD SNOWDON/CAMERA PRESS/RETNA. TOP: HARVEY/GAMMA/EYEDEA

The career of Princess Diana was multi-faceted, and it was watched at every juncture and event, large or small, by the whole world. She was called on to bolster galas and school functions, quite often on the same day, and she performed admirably at each. The lady clearly loved to dance, as is shown on the opposite page. Clockwise from top: She and her husband cut a rug in Melbourne, Australia, in 1985. In 1988, she truly steps out, performing ballet at a fundraiser for London's Royal Opera House. And in 1985, she swings beautifully with John Travolta at the White House. Nancy Reagan had told the actor, whose box-office clout was nonexistent at the time, that the princess would enjoy a spin. This picture appeared in LIFE., and Travolta later averred that Di directly led to his renaissance as a movie star: "That was an amazing moment because I was having a dip in my career and no one was interested in me. Suddenly I was the only one that mattered in America to Princess Diana, and I was reborn. I was, like, 'Wow! I matter to someone again!' . . . It was a wonderfully special moment of her fulfilling a dream and giving me a new value . . . I looked her in the eye and said, 'We're good. I can do this.'" Above: Four years after tripping the light fantastic with Travolta, Di is again on the move at her son's school in London, finishing ahead of the other moms. Left: A family portrait from 1991.

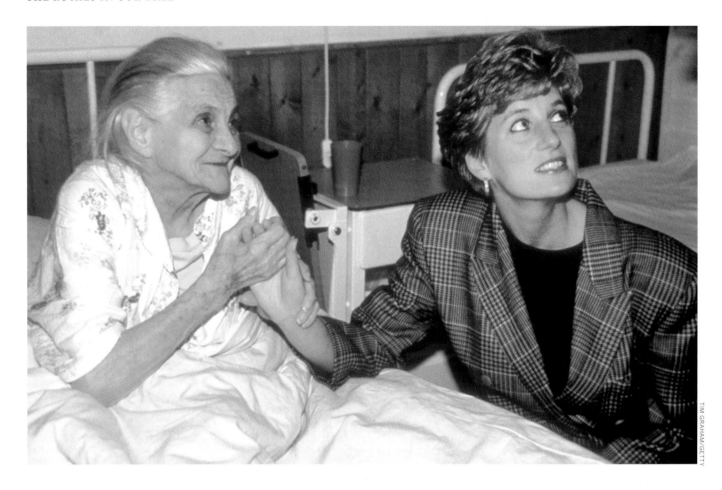

She found her best self and garnered the world's admiration as a humanitarian. She became a champion of AIDS awareness and worked to combat the scourge of leprosy. She assumed the presidency of the Great Ormond Street Hospital, a children's hospital. Later, she joined a campaign targeting landmines and the harm they did to innocents, particularly children—a campaign that would be awarded the Nobel Peace Prize in 1997. Above: Diana comforts an elderly Yugoslav refugee in Hungary in 1992. Below: On July 14, 1993, she serves food to children in the Nemazura refugee camp in Zimbabwe. Right: In 1997, only two months before her death, Diana bows to Mother Teresa at the Missionaries of Charity residence in New York City's Bronx borough. Opposite: That same year, she smiles upon Sandra Tigica, victim of a landmine, at the Neves Bendinha Orthopedic Workshop in Luanda, Angola.

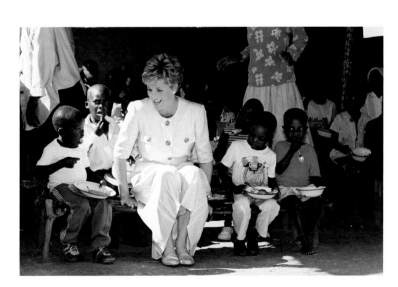

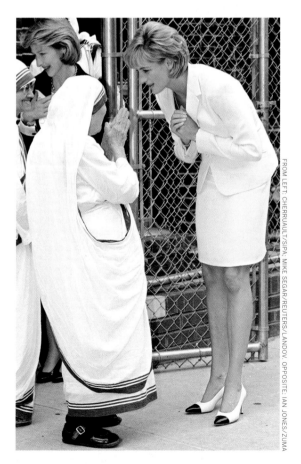

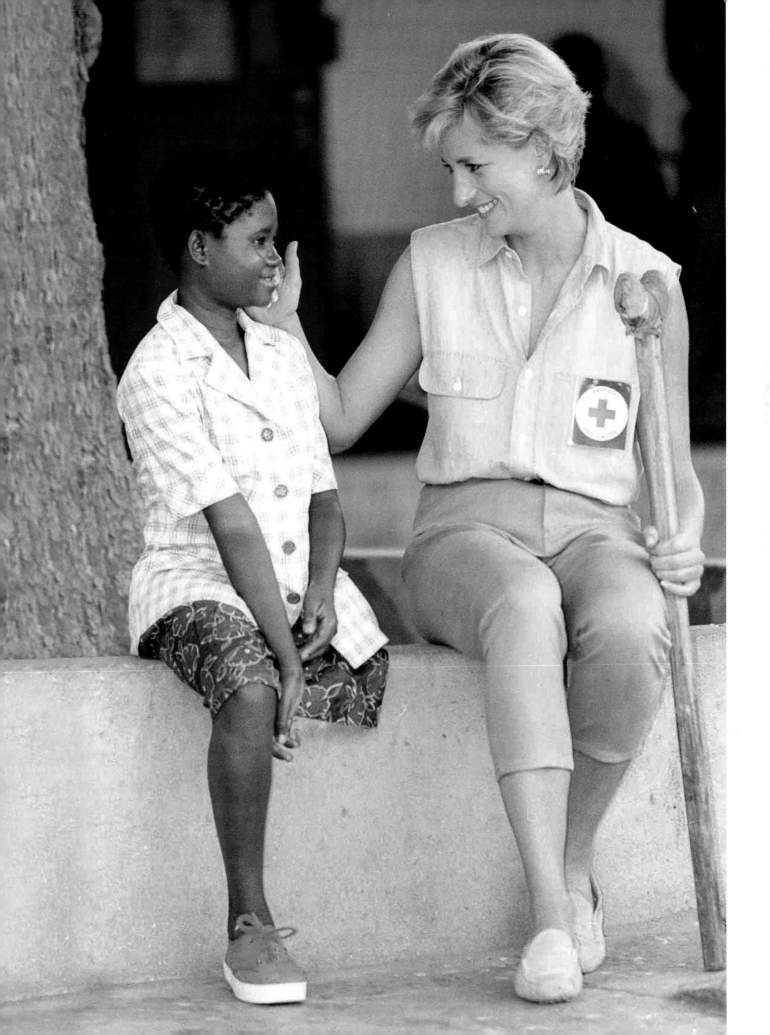

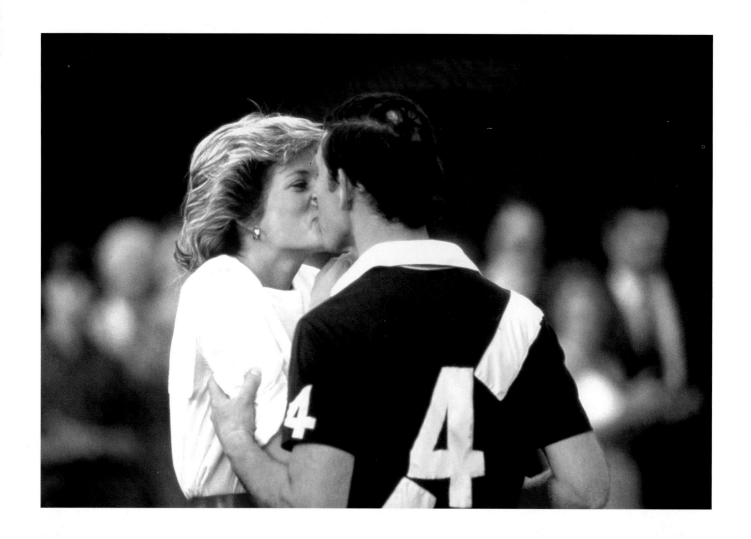

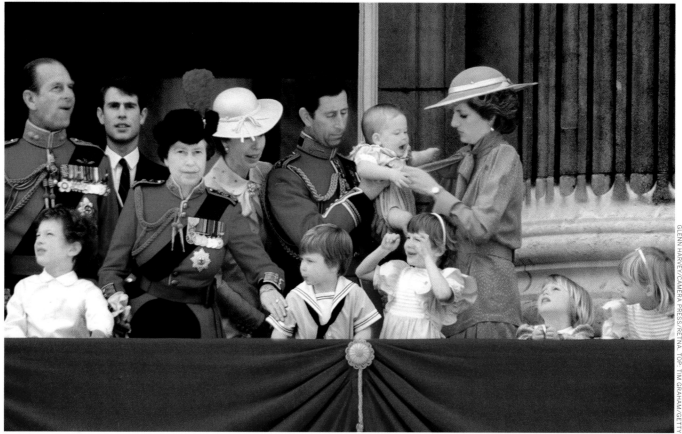

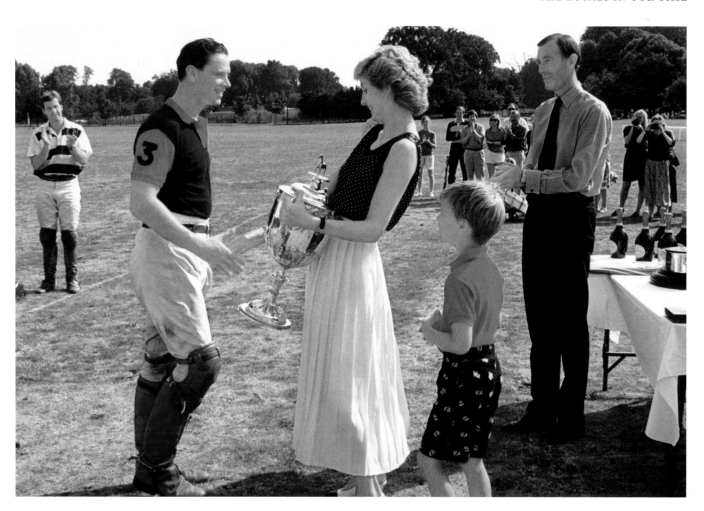

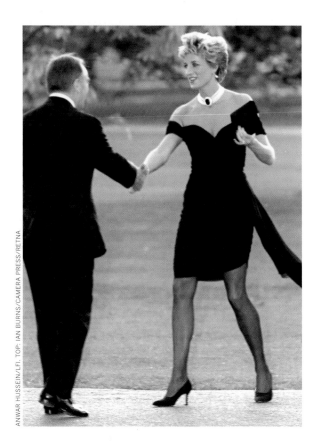

We now know that there was trouble in paradise almost from the get-go. Blame would be parceled, but a sticking point from the outset was the continuing presence of Camilla Parker Bowles as BFF of Prince Charles. Meantime, two boys would be born, and we will learn more about them on the pages immediately following. Opposite, top: Charles takes a break from his polo match to lift his wife's spirits with a kiss, in 1985. Bottom: During the same year's Trooping the Colour festivities, Charles is more than happy to hand over Prince Harry to Diana, as Prince William in his sailor suit looks toward the pageantry. Above: The most famous of Diana's several lovers, Life Guards Captain James Hewitt, accepts his spoils after another sporting contest, as Will watches. Hewitt will be called the "vilest man in Britain" by a London newspaper after he sells the inside story of his relationship with Diana to a rival tabloid. "You were morally entitled to give your side," insists Hewitt. "Money had nothing to do with it." That assertion is widely derided, and Diana is said to be "absolutely devastated" by Hewitt's public betrayal. It needs to be acknowledged that at times she was a woman who knew how to exact a measure of satisfaction—her pound of flesh—when her men went sleazy. A curious contemporary phenomenon is that of the "revenge dress," and its origin can be traced to 1994 when, on the day that Charles finally admitted his adultery, Diana showed up at a party sponsored by Vanity Fair magazine in the sexy black Christina Stambolian number seen at left. Take that, Wales!

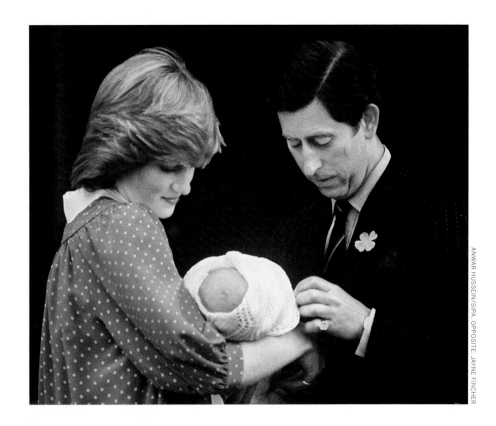

If there is one certainty above all others vis-à-vis Lady Di, it is that her sons meant the world to her—they became her reason for being. At left is a photograph of the royal couple leaving London's St. Mary's Hospital with William days after his birth on June 21, 1982. Opposite is a portrait from 1988, with Will on top and Harry cuddling. The boys inherited much from their mother: her lovely smile, her charisma, her empathy. Harry's ginger hair was a mite more gingerish than William's, and once Diana's affairs were disclosed, there was speculation that Harry was James Hewitt's son, not Charles's. The royals have bothered to say that DNA tests prove otherwise, and mathematics seems to indicate that Hewitt's late 1980s affair with Diana makes his siring of Harry, born in '84, unlikely, but the nattering class carries on. One can imagine that with such unseemly material swirling all about them, the lads would turn out to be great big messes; many a Hollywood child star facing lesser pressure has imploded. But Will and Harry march forth, in fine stiff-upper-lip manner. If there have been, as we will learn, isolated incidents, these have indeed been isolated and inconsequential. The Wales princes are, to use the term, "good boys."

ANWAR HUSSEIN/SIPA. OPPOSITE: JAYNE FINCHER

HEIRS APPARENT

I t is a safe conclusion that one or both of them will enjoy time as king one day; they are second and third in line behind their father. They are the Princes of Wales, William and Henry, the former known as Will and the latter as Harry. They were born in June 1982 and September 1984, respectively. Despite the pressures of their enormous celebrity from day one, and then the trauma of their mother's untimely death, they seem to have emerged from their adolescence as upright young men. Great Britain and fans of the royals throughout the world are happy to have them.

It has become increasingly clear in recent years that Charles is a devoted father, but credit for the boys' upbringing goes to Diana. Early on she asserted that she would be their mother in all ways. She chose their names; she dismissed a royal nanny and hired one of her preference. She dressed her sons, planned their birthday parties and playdates, selected their schools and escorted them to class as often as she could. She tried to remake her own busy schedule of talks, hospital visits and ribbon cuttings with an eye to their needs. The kind of proactive mothering she displayed was unprecedented in royal history.

After Queen Elizabeth advised Charles and Diana to divorce in December 1995, there was little doubt that Diana would be allowed to retain her rooms on the north side of Kensington Palace in central London, and that the boys would continue to live there and be raised by her. There was no estrangement from their father, but William and Harry were their mother's sons.

Their boyhoods were as normal as possible. The best the paparazzi could do for the longest time was file photos of Diana wiping ice cream off their lips or of Mom and the kids on a ski vacation in the Alps. Will, clearly, was as solid as the stone of Buckingham Palace; he was smart and handsome, destined to grow into something of a British JFK Jr. Young Harry was a bit of a roustabout. Attending Eton, which ran against the royal tradition of sending boys to Gordonstoun but was right in line with the Spencer way of doing things, he managed to pass a couple of A-levels but pulled a D in geography. He liked sports more than books, majoring in polo and rugby. In 2005, he thought it would be humorous to wear Nazi garb to a costume party, which only pressed home the fact that there are cameras everywhere—*everywhere!*—when you are an heir to the throne. That tabloid storm eventually quieted, and Harry's reputation would be largely redeemed with his service in the British military, in which he saw action on the front lines of the war in Afghanistan.

So, for the briefest time, Camelot: Charles, his beautiful princess and their two sterling sons. That would not last. But . . .

As we will learn in the pages to come, these sons head boldly into the new millennium, carrying with them the fate of their country's monarchy. Stepping smartly.

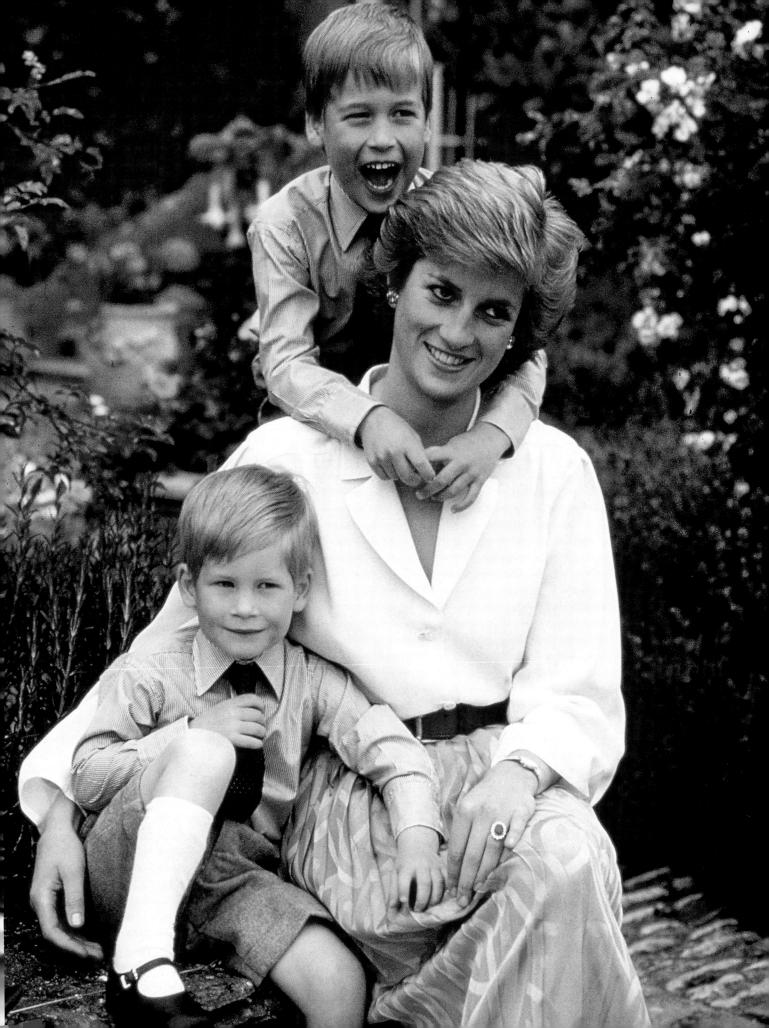

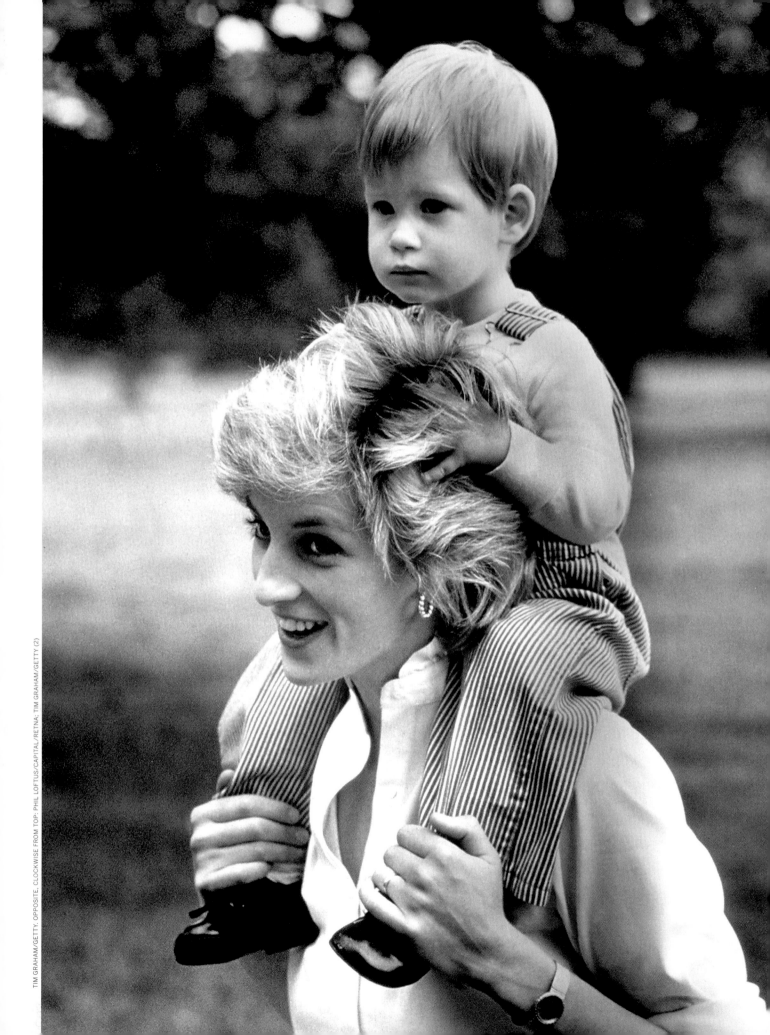

Clockwise from the opposite page: Di and Harry; Di and Charles on William's first day of school; Di with her boys on Harry's first day at the Weatherby School; Harry in very basic training. We will touch upon William and Harry's very good relationship with their father in just a few pages, but before we depart the Diana chapter, a few more words should be said—and are probably best said by the young men themselves who, in 2007, upon the 10th anniversary of their mother's death, sat down with the Today show's Matt Lauer. At one point, Lauer asked if they thought Diana would be pleased to see that they had grown up to be reasonably normal people. Harry, the more talkative of the two—then and always!—answered, "I think she'd be happy in the way that we're going about it, but slightly unhappy about the way the other people were going about it, as in saying, 'Look, you're not normal, so stop tryin' to be normal.' It's hard, 'cause to a certain respect, we never will be normal." Nor was their mother allowed to be, said Harry: "She wasn't always herself in the camera. She was much more natural behind the scenes when there was no one else there. I don't know whether it's the right thing to say, but she was quite good acting, if you know what I mean. She wasn't acting as though trying to be somebody she wasn't. But . . ."

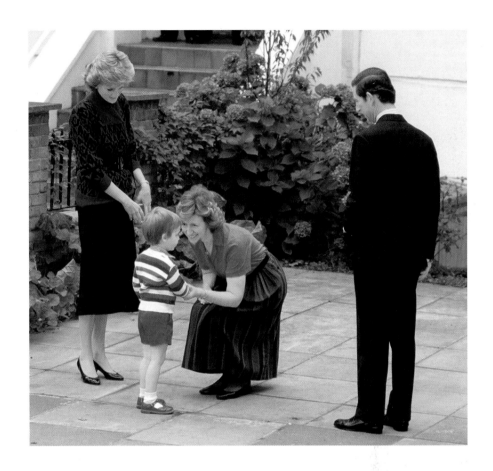

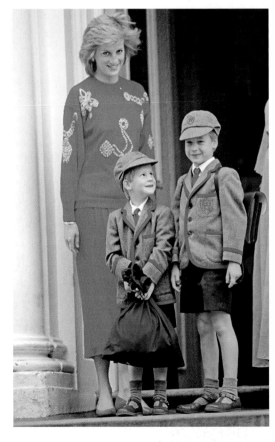

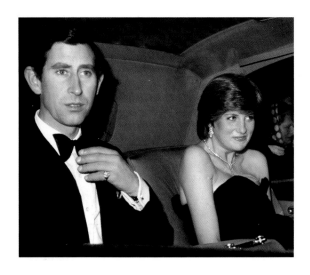

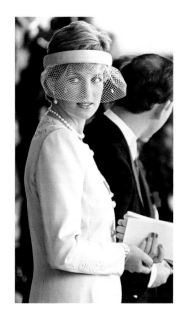

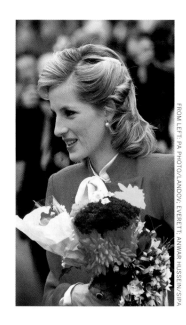

FROM LEFT: PA PHOTO/LANDOV; EVERETT; ANWAR HUSSEIN/SIPA

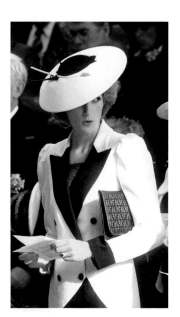

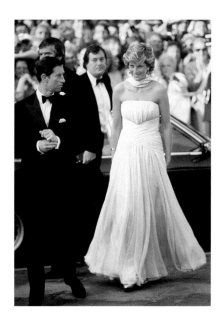

FROM LEFT: EVERETT; LAZIC/SIPA; TIM GRAHAM/GETTY

FROM LEFT: NEWSPIX/SIPA; ANWAR HUSSEIN/GETTY

We've already had a gander at Diana's smashing revenge dress (page 103), one of her most famous frocks, but it is proper that we should pause here and more fully salute this queen of fashion. On the opposite page, clockwise from top left: If she finished her royal career in risqué fashion with that previously seen in-your-face black gown, well, she started it the same way, donning a strapless, low-cut Emanuel for one of her first official engagements in 1981 and causing a minor scandal (the dress sold at auction to a Chilean fashion museum for more than $275,000 in 2010); a veiled attempt at modesty in 1992; the blasphemy of a different hairdo, forsaking her trademark "Di" cut in 1984; a Cossack look for a Christmas service in 1981; emulated by five New Zealand girls after her engagement is announced in 1981; in a stunning pink evening gown and diamond tiara, 1989; wearing a bold chapeau in 1985. Center: At the International Cannes Film Festival in 1987. If Di could make any clothes work, others of the royal family absolutely could not. Clockwise from top, left: The Queen Mum was legendary for her bad hats; had Andrew and Fergie's daughters been a bit more well-known, they certainly would have been too; the queen is in the pink in a comic tableau with guard and goat; Fergie seems a pitchwoman for Post-its rather than Weight Watchers; Charles and Camilla celebrate their first wedding anniversary in airy style at Balmoral; and Camilla chooses a curious topper considering that her last name once was Bowles, and that caption writers from here to eternity will have their way.

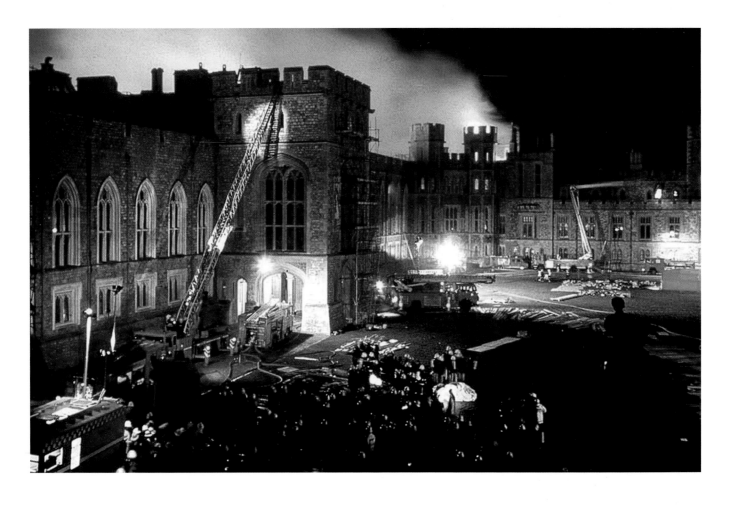

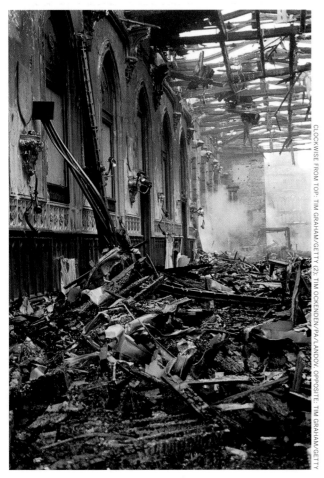

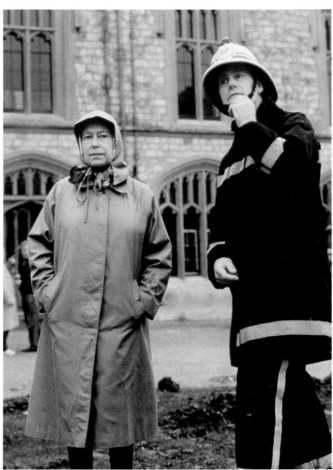

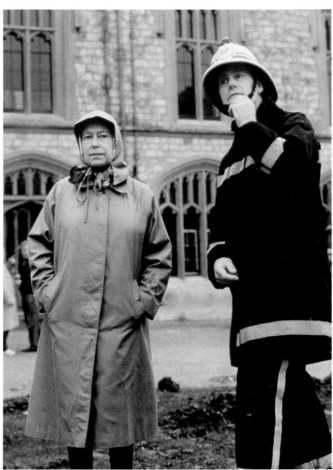

CLOCKWISE FROM TOP: TIM GRAHAM/GETTY (2); TIM OCKENDEN/PA/LANDOV. OPPOSITE: TIM GRAHAM/GETTY

THE ANNUS HORRIBILIS, AND MUCH WORSE

There has not yet been a collapse of the House of Windsor—they are a resilient bunch, to be sure—but the year 1992 tested the family sorely; the subsequent few years taxed them just as severely; and 1997 sent them to rock bottom. The misty aftermath of these many storms, marked by the crucial fact that their ship still sailed stoically on through the weather, was that the survivors were granted a new sympathy. As they bore on into the 21st century, the world was, largely, on their side.

Annus horribilis, a rather well-known phrase today, is a derivative term. Its clever antecedent, on the books at least since John Dryden's 1666 poem of the same name, is *annus mirabilis:* Latin for "year of wonders" or "year of miracles." Whenever things go extremely well for a while, you have an annus mirabilis. This was applied, for instance, in 1905 when Albert Einstein published four separate articles that changed the way mankind thought about space, time, matter—pretty much everything. The young physicist's works were dubbed the Annus Mirabilis Papers,

The Oxford English Dictionary says annus horribilis had appeared on the popular scene by the mid-1980s, but certainly only the most devoted linguists noticed it before November of '92 when Queen Elizabeth declared, "Nineteen ninety-two is not a year on which I shall look back with undiluted pleasure. In the words of one of my more sympathetic correspondents, it has turned out to be an annus horribilis." Di and Charles, aswirl in controversy, hadn't even announced their separation yet, though they would do so before New Year's Day.

What had happened already:

In March, Andrew and Fergie, on the heels of the topless photos, called it quits.

In April, Princess Anne, Elizabeth and Philip's daughter, divorced Captain Mark Phillips.

In June, Diana essentially coauthored *Diana, Her True Story*, which spoke of multiple infidelities and, in fact, was said to be an act of retribution aimed squarely at Charles and his mistress, Camilla Parker Bowles.

In August, taped conversations between Diana and one of her lovers, James Gilbey—the so-called Squidgygate tapes, after an affectionate nickname Gilbey had bestowed on Her Highness—were published in the *Sun*.

In November, Charles's Camillagate tapes, every bit as embarrassing as and even more graphic than the Squidgies, were transcribed in two other newspapers, *Today* and the *Mirror*.

Also that month, Windsor Castle burned. Serious damage and the queen's "annus horribilis" comment resulted.

And then in December, Charles and Diana confirmed what everybody already knew: that their union was no more and hadn't been happy for a goodly while. Their announced separation did nothing to take the spotlight off them. Paparazzi hounded Charles and Camilla daily and doubled-up on Diana and her new boyfriends, such as heart surgeon Hasnat Khan and then Dodi al-Fayed, scion in the family that owned Harrods department store, the Ritz Hotel in Paris and other interests.

Diana and Dodi died in an automobile crash in the Pont de l'Alma tunnel in Paris on August 31, 1997—traveling way too fast (which was certainly caused or exacerbated by the pursuing press) while chauffeured by the security manager of the Ritz, Henri Paul, who had been drinking.

It was one of the most stunning episodes ever in the long and incredibly dramatic history of the British royal family.

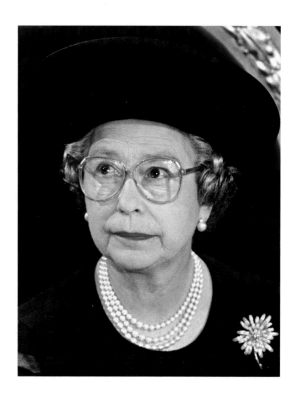

On the opposite page, Windsor Castle burns, and the queen is witness. Above: She is clearly moved as she delivers what is known as her Annus Horribilis speech. A sad irony is that her address was meant to commemorate a happy occasion: the 40th anniversary of her accession. But Elizabeth was so beset that she could not ignore the tempests engulfing her, and she talked as introspectively and poignantly as she ever has: "It is possible to have too much of a good thing. A well-meaning bishop was obviously doing his best when he told Queen Victoria, 'Ma'am, we cannot pray too often, nor too fervently, for the Royal Family.' The queen's reply was: 'Too fervently, no; too often, yes.' I, like Queen Victoria, have always been a believer in that old maxim, 'Moderation in all things.' I sometimes wonder how future generations will judge the events of this tumultuous year. I dare say that history will take a slightly more moderate view than that of some contemporary commentators. Distance is well known to lend enchantment, even to the less attractive views. After all, it has the inestimable advantage of hindsight. But it can also lend an extra dimension to judgment, giving it a leavening of moderation and compassion—even of wisdom—that is sometimes lacking in the reactions of those whose task it is in life to offer instant opinions on all things great and small. No section of the community has all the virtues, neither does any have all the vices. I am quite sure that most people try to do their jobs as best they can, even if the result is not always entirely successful. He who has never failed to reach perfection has a right to be the harshest critic. There can be no doubt, of course, that criticism is good for people and institutions that are part of public life. No institution—city, monarchy, whatever—should expect to be free from the scrutiny of those who give it their loyalty and support, not to mention those who don't. But we are all part of the same fabric of our national society and that scrutiny, by one part of another, can be just as effective if it is made with a touch of gentleness, good humor and understanding." Elizabeth, beset, pled.

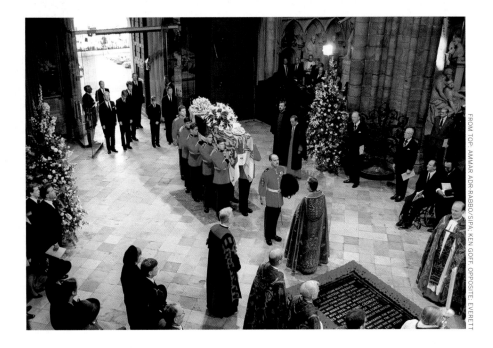

Just as we have chosen not to put on display in these pages the not-very-good and far too widely circulated paparazzi pictures of Fergie getting her toes pleasured or Diana exercising in the health club, we do not show here the hotel surveillance tapes proving that Diana and Dodi went to their car at whatever specific time—how does it possibly matter?—or the more graphic pictures of the accident itself. The facts are, she was with him, she was dating him, the trailing hordes of photographers chased them, their chauffeur Henri Paul (who was in the employ of Dodi's family) was driving under the influence of alcohol and prescription drugs, there was a terrible high-speed crash in the Pont de l'Alma tunnel in Paris, and all the passengers except a bodyguard died. Not to be harsh about it, but that represents case closed. At left, top, we see police investigating the scene of the late-summer, late-night accident. Below, Diana's casket is borne into Westminster Abbey during her extraordinary funeral—which was not a royal one, since she was no longer a princess, but was nonetheless the most attended-to passage perhaps in the history of the world. Elton John, who would later become Sir Elton, rewrote his Marilyn Monroe paean "Candle in the Wind" for his good friend Diana, and the world cried. Opposite, from top, four princes and a sibling: Diana's father-in-law, Prince Philip; son, Prince William; brother, Charles Spencer; former husband, Prince Charles; and son, Prince Harry.

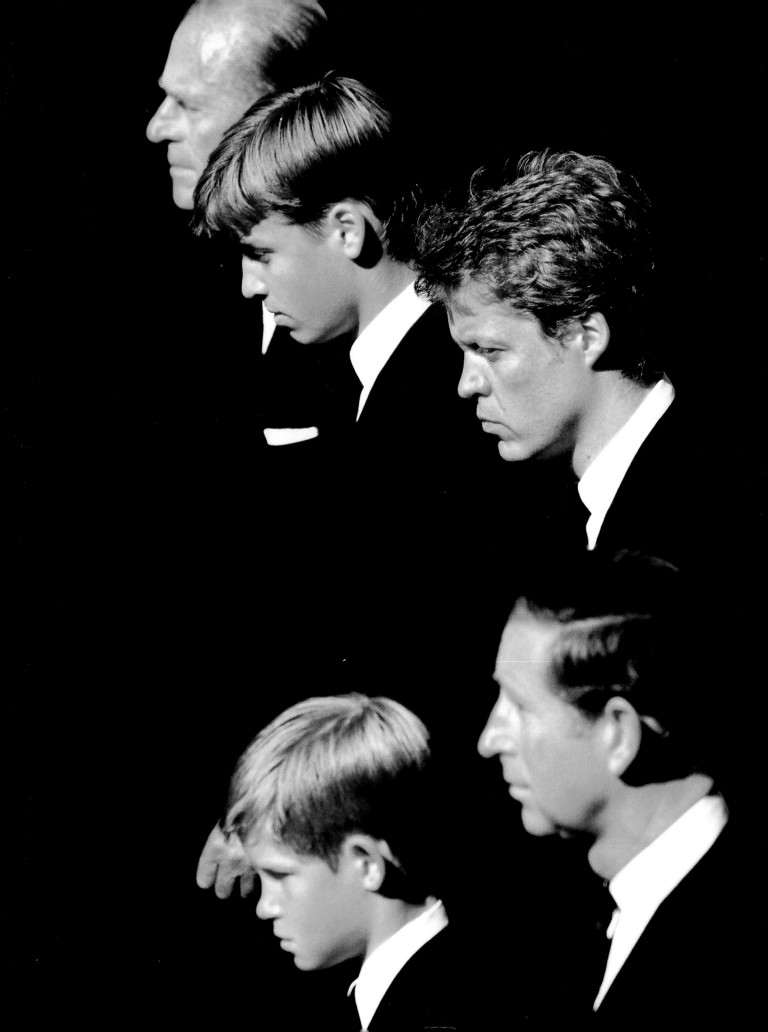

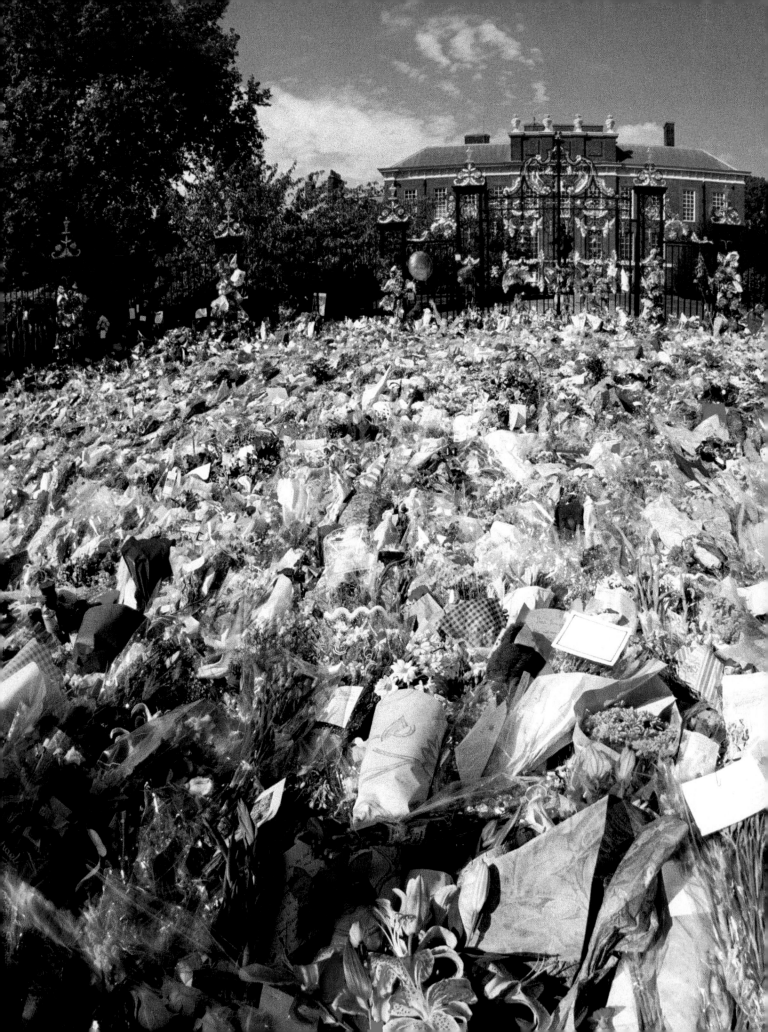

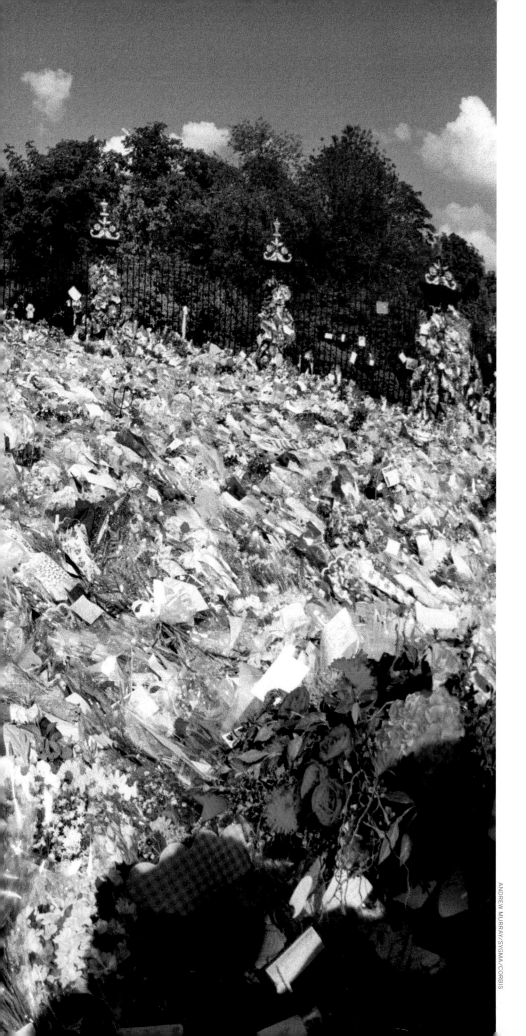

Few ever could have anticipated the out-pouring of emotion and abject communal grief that followed in the wake of Diana's death. It grew and grew and grew, swelling like a tsunami building as it approaches the shore. None seemed more surprised by the magnitude of the response than members of the royal family. Elizabeth was sav-aged by the press and public for what they perceived was an effort to downplay the tragedy—to dis Di. The queen eventually changed her tune, and joined in the Diana worship, issuing a statement praising the late princess and ordering that the Union Jack at Buckingham Palace be flown at half-mast, an honor that had been reserved for more than a millennium for the deaths of reigning monarchs. At the other end of Hyde Park from Buckingham, just across Kensington Gardens, flowers piled up outside Kensington Palace. Diana's devotees knew that this had remained her home even after her split from Charles. In the whirlwind of activity between the accident and the September 6 funeral, the Spencers established a charitable fund in Diana's name and collected $150 million in donations in a few days. Millions of people lined the route of the funeral proces-sion, and approximately half the world's population watched on television. Why? Theories abound; some are reasonable, and some seem half-baked. Diana's kindness and her public struggles—with her weight, with her marriage—had served to human-ize her, and when she stood in contrast to the rigid and often humorless Windsors the counterpoint was stark indeed. Perhaps there was a measure of remorse that we had gaped at and gossiped so about this young woman, even to rubbernecking at the car accident. In Britain, it could have been that the monarchy itself was being mourned: The citizenry loved this woman who had been cast aside more than they cared for the royals who survived. At the end of the day, Prime Minister Tony Blair put it simply and probably correctly: Diana had been "the People's Princess," and the people needed to say their goodbyes.

BRENDAN BEIRNE

April 9, 2005, was a most happy day at Windsor, not just for Charles and Camilla but for most of the hundreds in attendance including, crucially, William (at right in the photo above) and Harry, who, while never wavering in their devotion to their late mother, clearly welcomed the former Mrs. Parker Bowles as their stepmother. The civil ceremony took place at the Guildhall, then was followed by a Church of England blessing service at St. George's Chapel (opposite). These two events followed an extended period of controversy as to if and how Charles should marry again and what it might mean. In the run-up to the big day, academics and lawyers quarreled over whether Charles could even partake of a civil ceremony, as royals were excluded from such under the Marriage Act of 1836. But then: Maybe that exclusion had been overturned by the Marriage Act of 1949?! Whatever; the wedding was happening. But there were still situations: On February 17, 2005, it was announced that the venue was being changed from Windsor Castle to the Guildhall, Windsor, because holding a civil ceremony in a royal palace would allow commoners to ask for the same right. Then Pope John Paul II died, and the ceremonies were shifted back a day from April 8 so that the prince—and others among the global elite—could attend services in Rome. Nothing has ever been easy for Charles and Camilla. But, again: They were very happy this day, and so were most of their guests.

PHONE PALS

He has loved her for a long, long time.

As was the case with the scandal involving his Windsor ancestor Edward VIII and Wallis Simpson, the onlooking world couldn't quite understand this. Why is he carrying on in such a way? Princess Diana is such a beautiful young woman, such a loving mother. What's he thinking?

The ways of true love can rarely be explained to the satisfaction of outsiders. In this case, it needs to suffice as an answer that Prince Charles has loved Camilla Parker Bowles for a long, long time—at least as long ago as the 1980s, when the cell phone conversations that became the early-'90s Camillagate tapes were made. Their affair, therefore, began when he was still married to Diana, Princess of Wales, and Camilla was still with her husband, Andrew. When this was revealed, after Charles's public admission of adultery in 1994, the Roman Catholic Andrew quickly demanded and was granted a divorce. Charles and Camilla have been publicly together since the late 1990s, and they announced their engagement in early 2005. They wed later that year. Queen Elizabeth did not attend the marriage ceremony itself, though she was present at the Service of Blessing by the Archbishop of Canterbury, during which that humbling Act of Penitence (please see page 78) was recited.

Camilla, who today uses the titles Duchess of Cornwall and, when in Scotland, Duchess of Rothesay (deferentially eschewing Princess of Wales, an appellation also belonging to her), was born in 1947 and first met Charles at a polo match in 1970. She was a keen equestrian and knew how to fox hunt, so these two had things in common. She was briefly one of Charles's many girlfriends, but if he considered her marriage-worthy, others at Buckingham Palace thought not. She married Andrew Parker Bowles in 1973, and that seemed to be that.

But she never really left Charles's side. After the Camillagate transcriptions hit the papers, Diana, in an interview on the BBC, said that she had been aware of Camilla from the first: "Well, there were three of us in the marriage, so it was a bit crowded." In her private conversations Diana was less delicate, calling Camilla "the Rottweiler."

But Charles loved her and had loved her for a long, long time. Today he and his second wife share many residences: Clarence House in London, where the Queen Mum lived for decades; Highgrove House in Gloucestershire; the Birknall estate near the queen's Balmoral Castle in Scotland; and, since 2008, Llwynywermod (say it three times, fast), an elaborate farmstead in Wales. They are, by all accounts, most content.

DAVE HOGAN/GETTY. OPPOSITE: CHRIS YOUNG/AFP/GETTY

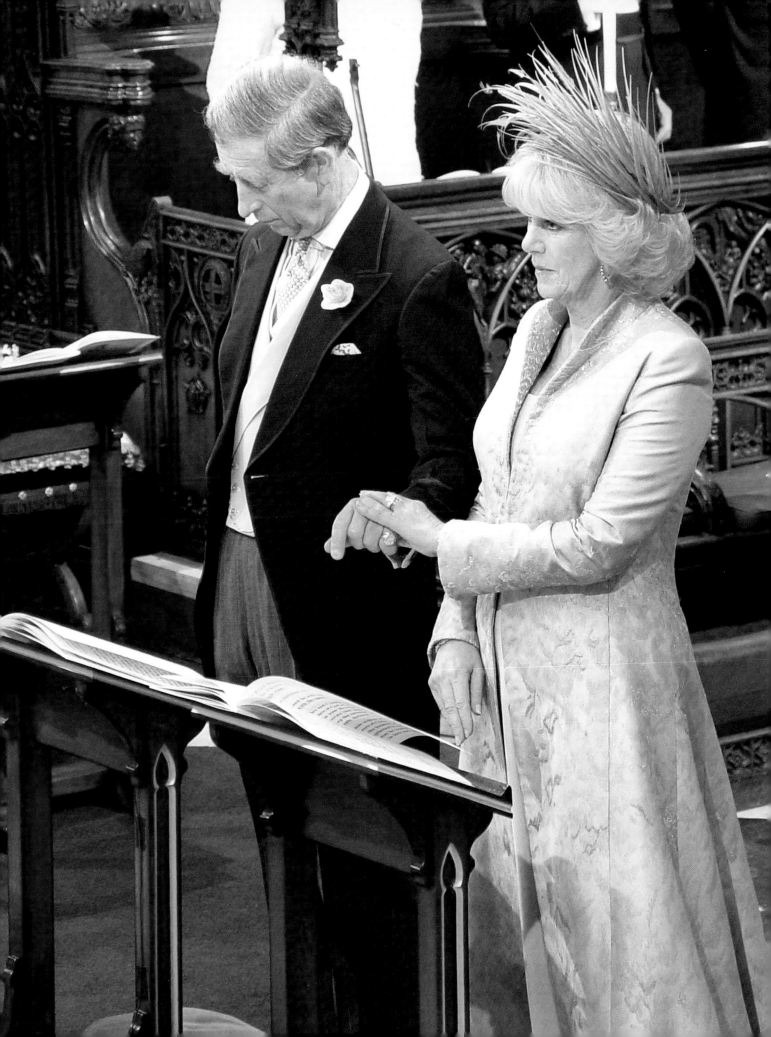

THE FUTURE

After the history we have recounted in these pages, how can we possibly say the monarchy is today in good hands? It seems the moment you look away, someone's doing something awful to someone else. And yet we confidently declare: The monarchy appears to be in good hands. Elizabeth II surely will not misstep before she goes to her just reward. Should it be Charles who inherits the throne, well, his maturity can be counted upon for a non-tumultuous reign, and the British can only be glad that Elizabeth has lasted long enough to ensure that assumption. And next are Will and Harry, who stand half a chance of being normal, clear-thinking adults because of the careful parenting of, in particular, their mother.

In recent years, the lads have shone. As said earlier, Harry, who attained the rank of lieutenant, truly distinguished himself with his military service in Afghanistan: This wasn't for show, he was in harm's way. Will, too, was a lieutenant in the British Armed Forces, and in 2008 chose to extend his enlistment and then transferred to the Royal Air Force; his operational tour therein, which might last for three years, begins in 2010.

Both brothers are, as their parents were (and Charles is still), engaged in philanthropy. But that's not what the world cares about. What the world cares about is that Will is in love with Kate, and that there may well be another royal wedding sooner rather than later. How many millions around the globe will tune in this time is anyone's guess (the bookies at Ladbrokes await your call).

William met the lovely, intelligent and sports-loving Kate Middleton in 2001 when both were undergrads at the august University of St. Andrews in Scotland. They've been a couple since 2003, with only a brief breakup in 2007 as a blip on their relationship résumé. Most royal observers think the long courtship is a good thing and feel that if Kate becomes Her Royal Highness one day, and then perhaps the queen, she may be able to handle it. In May 2010, when engagement rumors were heating up in earnest, Patrick Jephson, Princess Diana's former private secretary, told *People* magazine, "If she and the prince are strong in their marriage, then all these other things stand a good chance of coming out good." That's as much of an endorsement as a potential—presumptive—royal could ever hope for.

And so this ancient monarchy winds on inexorably into the future. William and Harry lead the way. A hundred years from now, perhaps a thousand, we'll write another book and let you know how they did.

Good luck, lads.

There is no longer any spin attached to this lovely portrait of a father and his sons, which was released to mark the 20th birthday of Prince Harry (at left) on September 15, 2004. Charles has always loved his boys and been good to them; if anything, he, the first-ever male British royal to attend the births of his children, has become an even better dad, day by day, through the years. But it is nonetheless a testament to all the Sturm und Drang that has barnacled the Windsors in recent years that when the photograph was first released to the press for free-of-charge use in '04, it was with the condition that "the feature including the image must be positive in content." The portrait is authentic: These are three happy men, and their mutual affection is genuine. But theirs has been an exceedingly strange—sometimes closeted, sometimes wide open—experience.

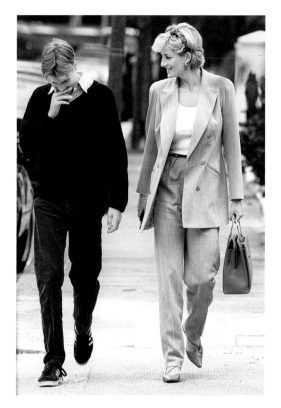

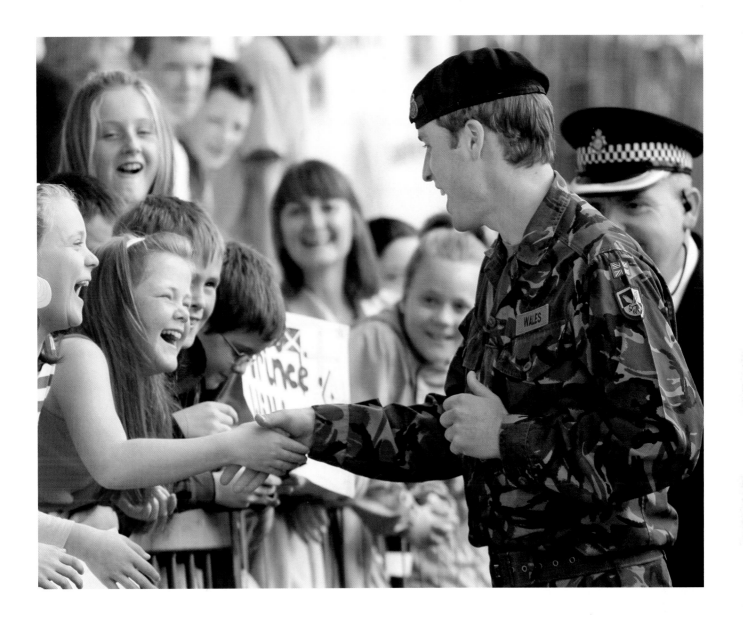

The boys' life: Every moment is and has always been scrutinized, every misstep recorded, every triumph celebrated. When Harry made the unfortunate decision that a Nazi getup would be the right choice for a costume party, the crummy, out-of-focus grabbed shot made the covers of tabloids worldwide, much as the cell phone picture of Michael Phelps smoking pot would years later, much as Aunt Fergie's pictures had years earlier. If ours is a world in which the famous person can get away with nothing, then William and Harry are truly upstanding young men, for the record against them is scant indeed. Regarding these fine photographs that constitute the other side of the ledger, we have on the opposite page, clockwise from top left, Harry and his father during a 2003 charity polo match in Windsor; William sharing a bon mot with his mother after dining at La Famiglia restaurant in London's Chelsea neighborhood in 1997; and Harry working with Matsu Potsane at the Mantsase Children's Home in Lesotho, Africa, where he is spending part of his "gap year" from school in 2004. Both boys have served their time in the military and continue to today; for Harry, this has become a defining part of his princely career, as we will see in the pages following. Above is Prince William, meeting naval families in Churchill Square, Helensburgh, in 2007. As the faces in this photo and particularly in the one at left, which was taken during a visit by both boys to high school students in British Columbia, Canada, in 1998, attest, Will and Harry are many things—heirs to the throne, celebrity magazine staples, good kids—but above all, and especially among the girls, they are rock stars.

It's a good thing that the cadets at the Royal Military Academy Sandhurst in Surrey are not held to the same standards as the Palace Guard at Buckingham when it comes to keeping a straight face, no matter what small or large distraction is put before them. If the cadets did face those expectations of stoicism, both Princes Harry (top left) and William (above) would have failed miserably upon being inspected by Her Majesty the Queen (also known by them as Grandmum) at two separate Sandhurst parades in 2006. Will completes his training at Sandhurst that year and is made a second lieutenant. Left: On May 7, 2010, Harry graduates from the pilot course at the Army Aviation Centre in Middle Wallop and, upon being presented with his flying wings by the Prince of Wales (also known by him as Dad), again cannot contain that infectious grin. Nor can the queen herself when, on the opposite page, she passes one of her exquisitely well-behaved men in Buckingham Palace in 2005. The reason for the fit of giggles is that the fellow beneath the prodigious bearskin hat is none other than the Duke of Edinburgh (also known by her as Philip, as in Prince Philip, as in Hubby). Situations like these arise all the time among royals, but the pictures do illuminate a Windsor characteristic: These folks really do enjoy one another, and in one another's company they exhibit a good humor that is too little seen by the public at large.

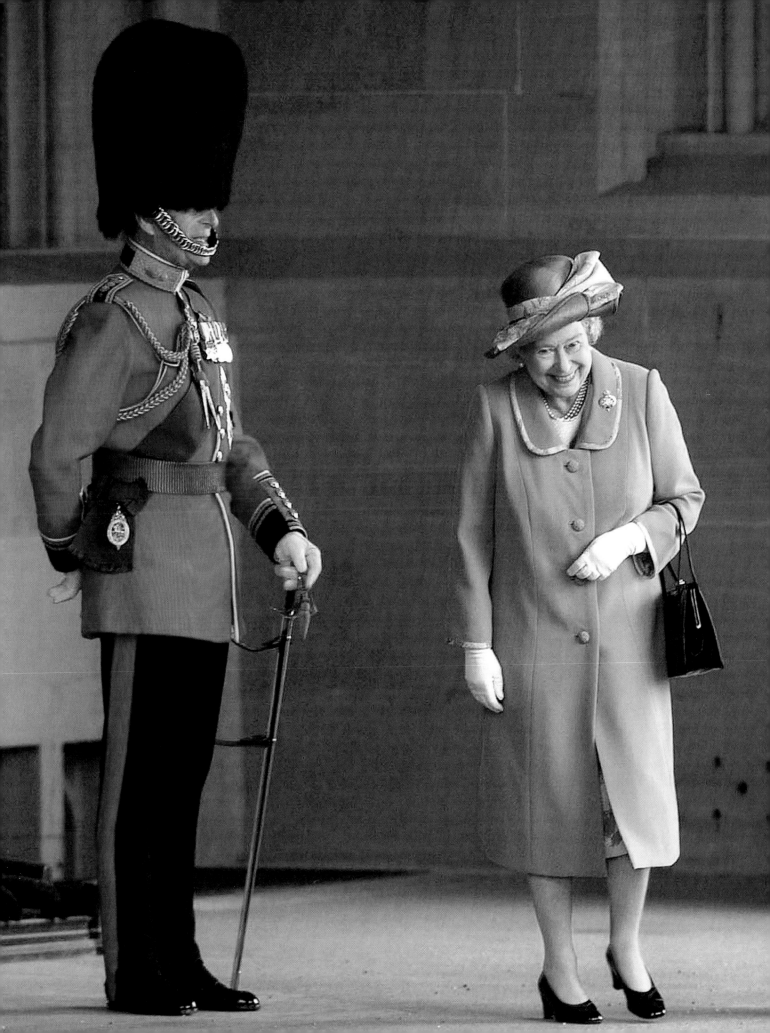

Both boys enjoy a good time and are described by their mates and colleagues as "normal"—even if, as we have seen, Harry feels they can never be completely so. Both are certainly dutiful. William applied himself in his studies at Eton College (seen here in 2000) and the University of St. Andrews, where he earned a Scottish master of arts degree with upper second class honors in geography, the highest marks ever achieved by an heir to the British throne. Upon graduating, he began his military career, which continues today. Harry was a student at Eton too, though the term applied more loosely, and he decided against higher education and later went into the service. Opposite, top: Young Harry shows his inclinations early as he rides in a tank during a visit to the barracks of the Light Dragoons in Hanover, Germany, in 1993. Bottom: In 2006 he aces his final training exercise in Cyprus before joining the Blues and Royals, part of the Household Cavalry, the oldest and most senior regiment in the British Army. During his tour of duty on the front line of the war in Afghanistan, he called in U.S. air strikes, helped repel an attack by Taliban insurgents and patrolled in hostile areas. After 10 weeks at the front, Harry was pulled back when his presence there was leaked by the media, making him a choice target for the enemy.

*Will she be queen one day? Only time
will tell, but speaking of time: Folks have
been asking that very question about the
lovely Kate Middleton for quite a long
time now, and recently the clamor for
the next royal wedding has increased in
volume. Middleton, the daughter of an
airline pilot and a flight attendant whose
family backgrounds were more blue- than
white-collar—but who struck it rich after
founding a mail-order party supplies com-
pany in 1987—was a university student
at St. Andrews in 2001 when she met and
began a relationship with Prince William.
They've been a couple for nearly a decade,
with a split and subsequent reconcilia-
tion in 2007. There have, of course, been
extraordinary pressures placed upon their
courtship; she has been harassed by the
press, and they have both been pushed by
the public to tie the knot (as when a com-
memorative-plate trial balloon was forged
in 2007, above). If William has issues—
he certainly witnessed constant bickering in
his parents' marriage, and well knows the
oppressiveness of public scrutiny and the
damage it can do—he doesn't talk about
them. He protects Kate as he can, and in
mid-2010 they were spending their time
together in North Wales, where Will was
completing his training to become a helicop-
ter pilot in the Royal Air Force. On May
3, 2010, the cover of* People *magazine
shouted* THE NEXT PRINCESS! *over
a lovely photo of the couple, and later that
year Will turned 28, an age which, he had
speculated earlier, might be a good one for
settling down. That this wedding the world
awaits is the affair of two people and two
people alone, and that a likely future king
and queen can't bring themselves to commit
utterly and eternally, is upsetting to some.
But to others—and these are the best of
the royals watchers—it's all great fun. It's
happy, it's gay. It's lovely, it's romantic. It's
regal, and it entertains us so. Huzzah!*

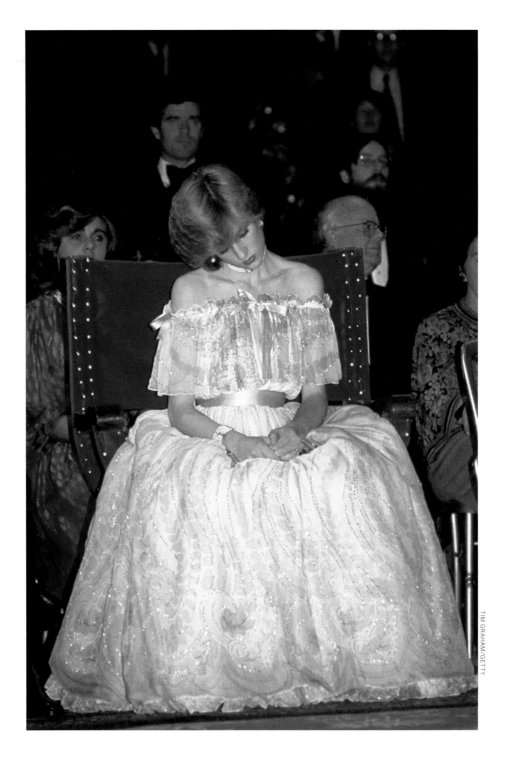

TIM GRAHAM/GETTY

JUST ONE MORE

With the exception of such as Anne Boleyn or Catherine Howard, no one has ever known how hard it is to be a royal more than Diana Spencer. Here, in 1981, pregnant with William, who most probably will be King William one day, Princess Diana nods off during a session of Parliament. No one blamed her then, and no one blames her now.